POSTCARD HISTORY SERIES

South Carolina Postcards

Volume IX

Anderson County

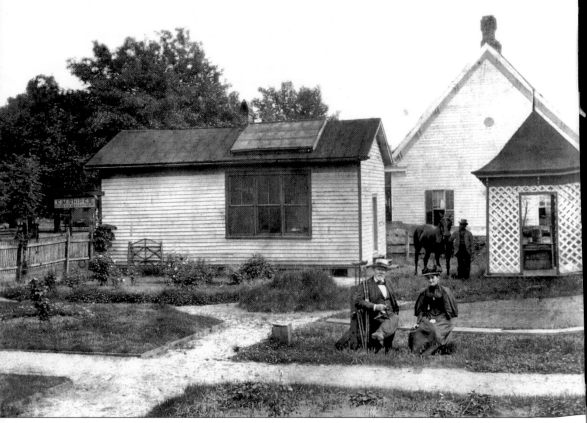

[Capt. John Daniels, 1901.] Capt. John Daniels and wife sit in the backyard of their home at Main and Church Streets. The studio of Elbert M. Snipes, photographer, active from 1892 to 1910, is on the left. A covered well is in the center right with the rear of the Daniel Home in back center. This site was future home of the Kress store. John W. Daniels was Anderson's clerk of court from 1865 to 1884 and a member of the South Carolina House of Representatives from 1887 to 1888.

Front Cover:

[Concord School Class, 1902.] The 1902 rural Concord School was one of the four schools in Centerville School District #6, which had 241 students in 1900. Initially, the supporting Concord Church was Presbyterian; however, the sanctuary was sold to a Baptist congregation in 1904. Later, Hopewell School District #7 was divided and the western half was called Concord School District #66. The school's site was between S.C. 81 and U.S. 178. The 1902 class was taught by Miss Eva Gentry. Gunter's 1918 comprehensive Superintendent of Education's Anderson County school review stated that the school had 24 students in grades 1 through 8. Older students went to Anderson High School.

Back Cover:

[Anderson County Court House, c. 1906.] Each of Anderson County's courthouses was built in the center of the public square beginning with the 1827 creation of the village site. The village grew and the public square became the business center for the town. The 1898 Anderson County courthouse was the center for the 1906 Gala Week. This gala event was created by the city leaders to encourage the establishment of other businesses in Anderson.

POSTCARD HISTORY SERIES

South Carolina Postcards
Volume IX
Anderson County

Howard Woody

ARCADIA
PUBLISHING

Published by Arcadia Publishing
Charleston, South Carolina

Printed in the United States of America

Library of Congress Catalog Card Number: 2003104601

For all general information contact Arcadia Publishing at:
Telephone 843-853-2070
Fax 843-853-0044
E-Mail sales@arcadiapublishing.com
For customer service and orders:
Toll-Free 1-888-313-2665

Visit us on the Internet at www.arcadiapublishing.com

For my grandchildren: Cassie, John, Jenna, Allie, Haylei, and T.J.

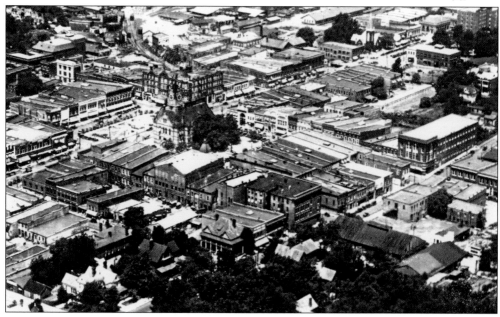

[AERIAL VIEW OF ANDERSON, 1929.] This aerial view of Anderson was taken in 1929 from a position southeast of the courthouse in the public square, which is located in the left-center of the picture. The north side of East Whitner Street is shown from the square eastward to McDuffie Street, the diagonal street in the lower right. The square's park, the Confederate Monument, and the west side of the square (now the site of the 1991 courthouse) are located in the center left side of this view.

CONTENTS

Introduction 7

1. Anderson Town 9

2. Anderson Cotton Mills 57

3. Western Anderson County 65

4. Eastern Anderson County 95

Acknowledgments 127

Index 127

INTRODUCTION

The search for historical images that reflect the evolving culture of South Carolina at the beginning of the 20th century continues with Anderson County, volume nine. This Postcard History Series that began with related multi-county volumes has followed a pathway starting in Charleston, then Beaufort and the Lowcountry (volume two), and Aiken and the west central section (volume three). "Midlands" books were *Lexington County* (volume four), *Richland County* (volume five), *Newberry County* (volume six), and *Kershaw County* (volume seven). *Camden* became volume eight, and *Anderson County* is now volume nine.

The Indians inhabited South Carolina from the earliest times. The first Europeans to visit Anderson County were in the Spanish explorer Hernando De Soto's expedition, passing up the east side of the Savannah River Valley through Anderson County in May 1540. De Soto sought gold and asked the Cherokee Indians where it could be found and his quest led him west into Georgia. In 1757 a treaty with the Cherokee Indians opened all their lands in lower South Carolina up to the northwest area to the European settlers.

During the Revolutionary period several individuals became prominent in the area that would become Anderson County. Robert Anderson, from Virginia, surveyed this area in 1765 and then settled in the Pendleton area. Gen. Andrew Pickens and Anderson were leaders in the military campaigns at Cowpens and elsewhere. General Pickens negotiated the Cherokee treaty of 1785. The 1785 legislature decreed that the Saluda River would divide the Indian lands with the eastern section becoming Greenville County, while the western half would be Washington County. In 1789 Washington County was renamed Pendleton County for Judge Henry Pendleton. In 1800 the legislature did away with counties and renamed them judicial districts. In 1826 the Pendleton Judicial District was divided into Anderson District and Pickens District. After the peace with the Indians, settlers including the Scots and the Scots-Irish traveled south on the Great Philadelphia Wagon Trail in covered wagons from Virginia, Maryland, and Pennsylvania. The white population in 1790 was 8,731 and increased to 17,760 in 1800. Scots-Irish were the main ethnic group with some Quakers, Welsh, and others having smaller percentages. Later, Lowcountry planters and others built summer homes to escape the natural conditions of that region.

The 1826 act creating Anderson District set in motion the requirement of a courthouse site. The village site was selected in 1827 by Robert B. Norris and Matthew Gambrell surveyed the site and created a village of 130 acres with a square in the center and streets leading there from each direction. Benjamin Denham was awarded the contract to build the first courthouse that would be in the center of the square.

Initially, only Indian trails passed through the county and extended south and east to the communities along the coast. The early settlers used these routes. Later, the Savannah River became a major shipping route to Augusta. The town of Andersonville, at the junction of the Tugaloo and the Seneca Rivers where they formed the Savannah River, became a major shipping town. However, a large freshet in 1840 destroyed the town and that site is now under Lake Hartwell. The final blow to Andersonville was the construction of the Greenville and Columbia Railroad in 1853, which bound the counties together with faster and cheaper land transportation. Then in 1856 the Blue Ridge Railroad connected Pendleton to Walhalla and in 1885 the Savannah Valley Railroad became a direct route to Augusta.

Anderson County continued to evolve with small towns growing from the depot sites and along the major paths to nearby towns. The land was productive and small farms and larger plantations thrived with corn, cotton, grain, and tobacco crops. The Civil War disrupted the evolution of Anderson County and South Carolina. After the firings on Fort Sumter in April 1861 and Governor Pickens's call for volunteers, the 4th South Carolina Regiment, which included the Palmetto Riflemen, was formed. Anderson volunteers also belonged to the 2nd South Carolina Regiment, the 18th and the 20th South Carolina Regiment, and Hampton's Legion, among others. On May 1, 1865, Union troops came to the town of Anderson looking for the Confederate Treasury and its gold. Instead, they found a large stock of fine liquor in the cellar of the B.F. Crayton building and became drunk and did not burn the town.

In 1868 D.T. Corbin introduced an act in the South Carolina senate to create townships and to define their responsibilities. Anderson County's 16 townships were Brushy Creek, Garvin, Williamston, Hopewell, Pendleton, Fork, Centerville, Broadway, Belton, Honea Path, Martin, Varennes, Rock Mills, Savannah, Hall, and Corner. These townships were conveniently used to form school districts. The education of urban and rural children became a major stepping stone in the development of the county. Early schools included Pendleton Academy, 1811; Thalian Academy, 1830s; Pearl Spring, 1837; Moffattsville Academy, 1870; Carswell Institute, 1876; and others in the various towns. About 225 schools were in the county in 1901. The Rosenwald Fund assisted black education.

Near the end of the 18th century, industries related to Anderson's cotton crop began to develop where railroads came close to creeks and rivers. Cotton mills were constructed to use water power to produce fabric from the cotton of this county. The Anderson County mills processed over three-fourths of the county's cotton production in 1901.

In 1894 the High Shoals hydro-electrical power plant, some six miles from Anderson, began transmitting the first long-distance electric power in the South. Then a Portman Shoals Power Plant on the Seneca River was built that used generators giving 11,000 volts that passed over wires 10 miles long. The plant caused Anderson to be called the "Electric City." In 1900 the numerous Anderson mills, the 731 square miles of productive land, and good crops supported by 2000 miles of roads created a taxation of $7,127,785 on personal and corporate income. Anderson was the fourth wealthiest county in South Carolina in 1901. The future for Anderson County was bright.

Questions have been asked about the pictures in these books. Where were they found? What is a postcard image? The answers relate to the intended or extended use of the subjects on the photographer's negatives. Initially, pictures were taken for announcements, advertisements, and newspaper or family uses. These images could be made full scale for postcards, enlarged for framing, or reduced for montage uses.

The scales of the pictures in this book have been altered to relate to page layout and length of caption. Additionally, "titles" that appear on the front of some postcards begin each image's accompanying caption; where views have no title or date, the author has created one and inserted it between brackets.

The object of the previous books in this South Carolina Postcards series has been to produce a body of images that reflect the lifestyles of the pre-1890s to 1930s culture of a county. I hope that the two-fold experience of edification and enjoyment is found in this volume.

Howard Woody

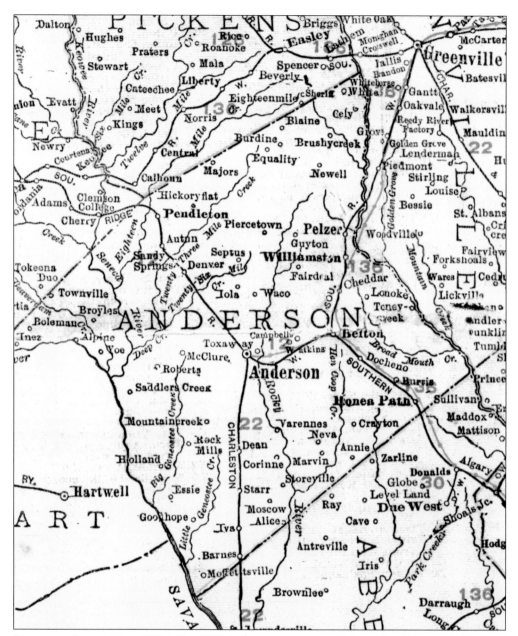

[ANDERSON COUNTY MAP, 1910.] The 1910 Anderson County map's boundary lines are being used to indicate the locations of sites. South Carolina State Highway Department's Anderson County 1937 and 1966 maps are used to obtain federal, state, and county highway numbers. Highway codes are U.S. for federal roads, S.C. for state highways, and A.C. for Anderson County roads. Contemporary maps are used for 2002 road names. Historic Anderson County 1877 and 1897 maps were used to locate township boundaries and sites.

One

ANDERSON TOWN

The town of Anderson evolved from a pre–Civil War village, the fire of 1845 that destroyed the west side of the public square, and the burdens of the Reconstruction period. The railroad lines connected it to the economic centers of the state. By the end of the 1880s each side of the square was filled with thriving retailers, several of which had a volume of business from $100,000 to $200,000. In 1890 water, electric, and ice plants were servicing the city. The first of a series of cotton mills was in production in 1890. A modern courthouse and a city hall with a fire station were built in 1898 and a public school system was in place in 1896. All the segments of a major economic center were in place by 1900 and Anderson became a regional hub for industry.

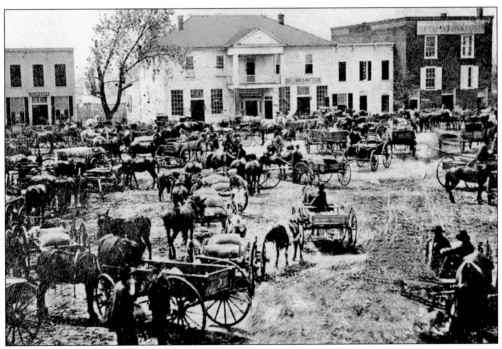

[ORR'S "CENTENNIAL HOUSE," 1876.] This East Benson Street block shows the public square's south side. On the left was the Fant and Son building, and next was the Christopher Orr Hotel (*c.* 1845), which was renovated in 1876 and called the "Centennial House." The first floor had Orr's tavern and a retailer, while the second floor had rooms for hotel guests. On the far right of the scene, Col. B.F. Crayton built his store, which in 1865 saved the town from being burned.

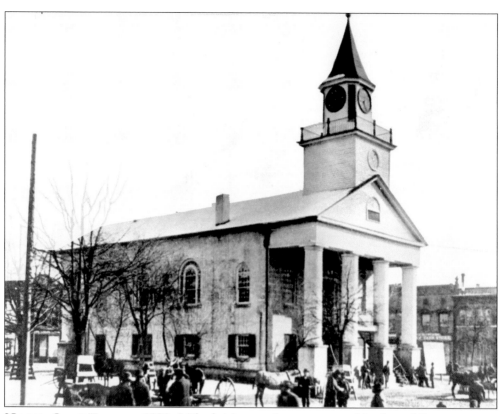

[COUNTY COURT HOUSE, c. 1890s.] The brick court house, centered in the public square, was erected in 1826. The exterior of the brick structure was plastered in 1851 and in 1852 a portico with four large columns was added to each end along with a belfry and bell to the western end at a cost of $2,500. A clock was placed in its steeple in 1877. The building was razed in 1897 and the next courthouse was erected on the same site in 1898.

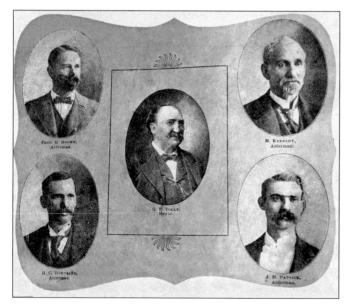

[ELECTED OFFICIALS, ANDERSON, 1900.] This 1900 montage of Anderson's elected officials (1900–1902) includes Mayor G.F. Tolley (center) and four Aldermen, (clockwise from top left) F.G. Brown, M. Kennedy, J.M. Patrick, and H.C. Townsend. Mayor Tolley was first elected in 1878 and served the city for 19 years. The city tax valuation was $1,765,000 in 1900 with a city tax of 1.55%. The bonded debt was only $50,000. The total city expenditures for 1900 were $30,934.

[Gov. James L. Orr, 1870.] James L. Orr (1822–1873) was born in Craytonville in Pendleton District, practiced law, and served in the South Carolina House of Representatives (1844–1848). Orr was elected to the United States Congress (1848–1858) as a member of the States Rights Democratic Party and became speaker of the United States House in 1857. Orr was elected governor of South Carolina (1865–1868) as the state's first to be elected by direct popular vote. Later, he served as a circuit court judge. Orr was appointed United States Minister to Russia by President Ulysses Grant in 1872 and died there in 1873.

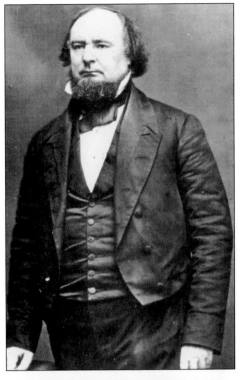

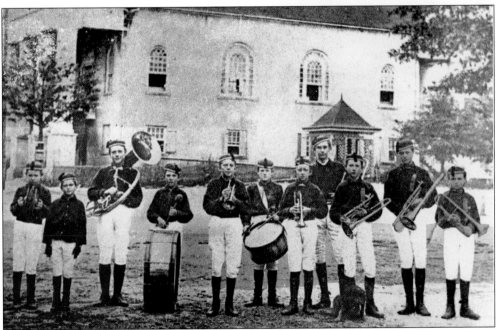

[Brass Band, County Courthouse, 1885.] Anderson's brass concert band was assembled in the public square beside the 1880s courthouse for an official portrait. The band had returned from a Greenville band competition where it won a $50 prize. The band was the major entertainment source for public events and parades in the city.

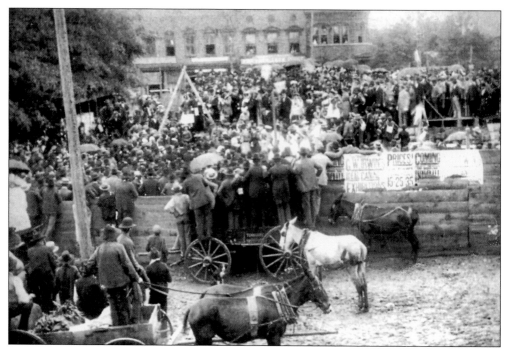

[LAYING OF COURTHOUSE CORNER STONE CEREMONY, 1897.] Since the same site was used for each courthouse, the previous one had to be razed and the site cleared before the next one could be erected. This 1897 view documents the ceremony assembled to observe the placing of the corner stone for the 1898 courthouse.

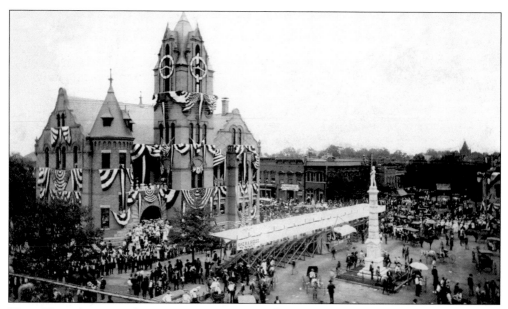

[GALA WEEK, ANDERSON COUNTY COURT HOUSE, 1906.] The Gala Week event shown above was organized by city officials to attract new trade to Anderson. The architect of this new courthouse was Frank P. Milburn, who bought second-hand plans from Winston-Salem for $50. The building cost $26,000 and was dedicated on June 27, 1898.

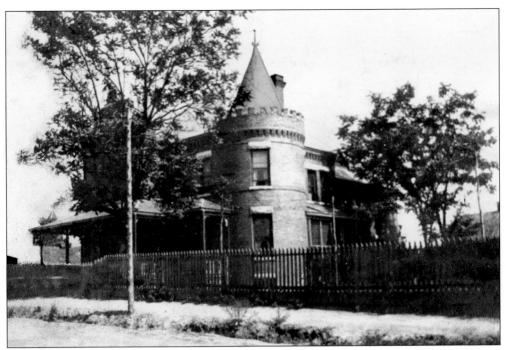

[CITY JAIL, *c.* 1910.] When the 1898 courthouse was completed, the remaining $9,000 was used to build the jail, pictured above, at 125 West Church Street near the corner of Jail (Murray) Street. The front looked like a residence and the sheriff and his family lived in the front section. Supervisor W.P. Snelgrove used the same second-hand plans from Winston-Salem, North Carolina to build the jail. The last public hanging occurred on March 4, 1902.

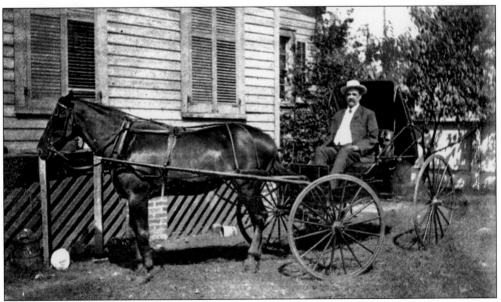

[PORTRAIT OF ASA HALL, LEGISLATOR, *c.* 1907.] J. Asa Hall was a member of the South Carolina House of Representatives from 1905 to 1908 and from 1913 to 1914. This postcard view shows him in his buggy by his residence at 1205 South Main Street.

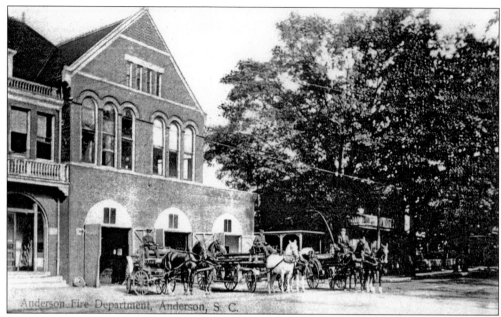

ANDERSON FIRE DEPARTMENT, [*c.* 1909.] This postcard view shows the fire department that was housed in the ground level of city hall at 403 South Main at Market Street. W.C. Smith, chief of the fire department in 1911, lived in the house beside this building. The two white horses in the center were named Frank and Jim (the pinto). Each horse was trained to respond to the fire bell and be ready to go to the fire.

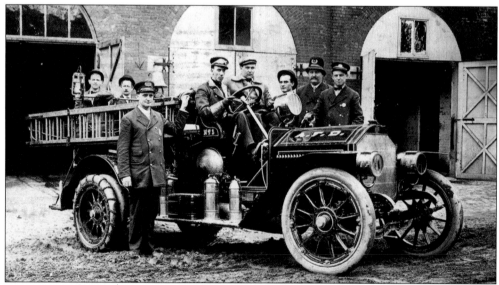

[FIRST FIRE TRUCK, 1912.] The Anderson City Fire Department's first motorized fire truck was bought in 1912 after a citywide debate over the purchase during which Victor Cheshire, editor of the *Intelligencer*, was shot but not killed. Standing beside the truck is Chief Jackson, the first paid fire chief in Anderson. All the other firemen were volunteers. This type of truck had no tread on its tires; however, the back tires had chains to get out of muddy sites. The truck remains in the fire department's museum.

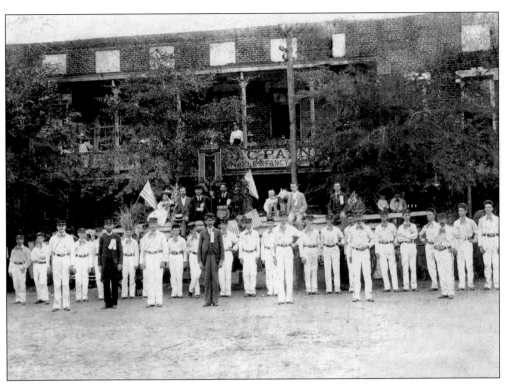

[INDEPENDENT HOOK AND LADDER COMPANY, 1891.] This 1891 portrait of the volunteer firemen was taken on the sixth anniversary of the Independent Hook and Ladder Company. They stood in front of the Brick Range. This company grew and evolved into the Anderson City Fire Department, which was supported by 195,000 gallons of water in the city's stand pipe.

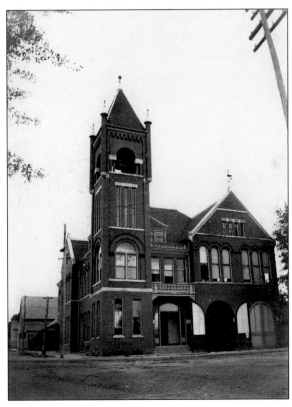

[CITY HALL & FIRE STATION, C. 1905.] The Anderson City Hall was built in 1898 and housed the fire department, which in 1901 had three teams of 120 volunteers. The postcard on the top of page 14 shows the two white horses in the middle, which were named Frank (left) and Jim (right). When Frank got old, he was sold to a street fruit peddler. When the fire bell was heard, Frank would turn and race towards the station, scattering fruit along the way.

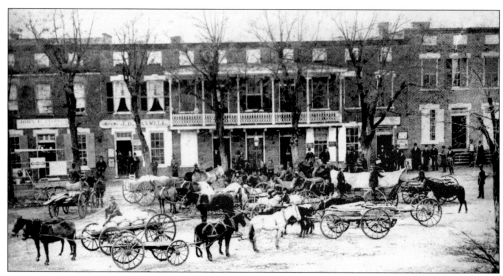

[BRICK RANGE (WEST SIDE), 1876.] This row of red brick buildings, on the west side of the public square, was built after the fire of 1845. Early occupants of the Brick Range began with Von Bostell's Jewelry Store, the Bank of Anderson, Julius Poppe's Tavern, J.D. Maxwell, G.W. Fant & Son Book Store, Williams Store, and Van Wyck's Bakery. In 1905 this area in front of the Brick Range was made into a grassy park and the site for the Confederate Monument. This block was razed and it became the site for the 1991 courthouse.

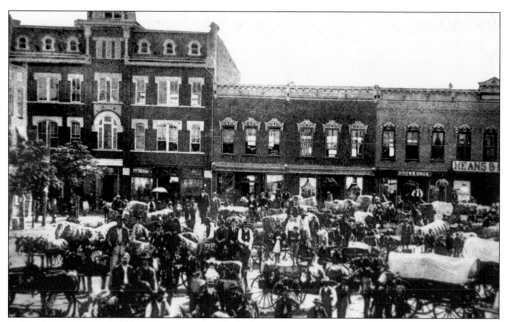

[MASONIC TEMPLE AND OPERA HOUSE (SOUTH SIDE), c. 1889.] Benson Street, the south side of the square, continued to change with the razing of Centennial House. A brick block erected that included the Crayton Building (1885) and the Masonic Temple (1889) at 118–120 Benson Street was built, with the Opera House on the top floor. Vaudeville shows were performed there and when horses were included in the acts the animals walked up the stairs to the top floor. The building still stands in a remodeled condition.

[G.W. FANT AND SON, *c.* 1884.] George W. Fant obtained T.J. Webb's bookstore in 1851. The G.W. Fant bookstore was first in the Brick Range at 511 (106 South Main Street.) Standing in front of the store, from left to right, are Charles Langston, George W. Fant, Will Webb, and Rufus and Theo Fant. Later, the Rufus Fant and Brothers bookstore moved to 209 West Whitner Street. The Brick Range store site was shown on the 1884 Sanborn Insurance Company map, while the 1890 and later maps showed the Whitner Street site.

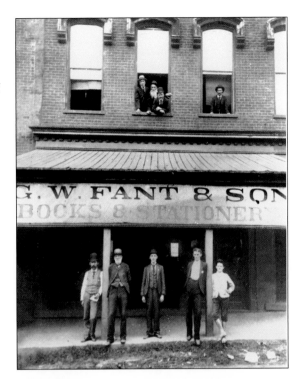

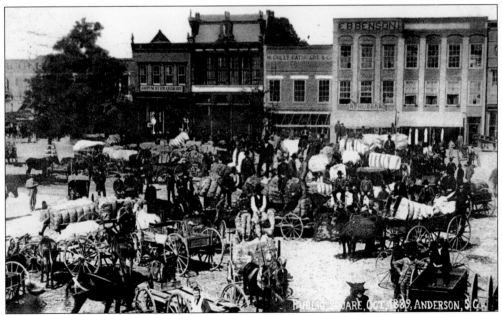

PUBLIC SQUARE (NORTH SIDE), OCTOBER, 1889. This October 1889 postcard view of the public square shows the open dirt lot behind the courthouse filled with farmers' wagons. The north side (initially Depot Street, later East Whitner Street) is in the background. The first building on the left is the John Hubbard Company (jewelry store), then the Farmers and Merchants Bank (1882), the McCully-Cathcart Company, the E.B. Benson Store, and A.P. Hubbard's Store. Later, the Gallant-Belk Department Store was located on that side.

17

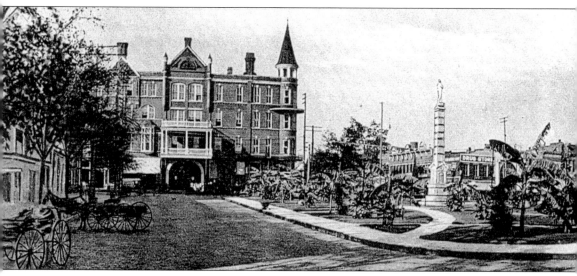

PANORAMA OF COURT HOUSE SQUARE, [*c.* 1909.] This postcard scene shows the 1898 courthouse and the initial spacious public square that surrounded the courthouse, which was lost when the 1991 court house replaced the park and the Brick Range. The left side of this panorama, taken from the southwest corner, begins with the trees in front of the Brick Range (west side) and the Hotel Chiquola on the northwest side. The park's foliage obstructs the distant East Whitner

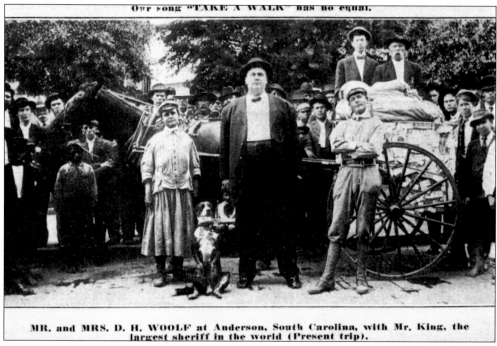

MR. and MRS. D. H. WOOLF at Anderson, South Carolina, with Mr. King, the largest sheriff in the world (Present trip).

MR. AND MRS. WOOLF AND MR. W.B. KING, [*c.* 1910.] The "Walking Woolfs," like some other families during the first decade of the 20th century, toured the country as they walked from one community to the next. They had their picture taken with local celebrities and postcards with that image were sold. W.B. King was Anderson's sheriff from 1909 to 1911 and lived at the jail residence at 125 Church Street. He claimed to be the largest sheriff in the world.

18

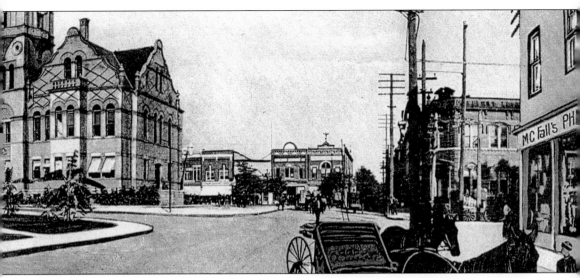

Street (north side) of the Square and the courthouse blocks the Granite Row (east side) back of the Square. Halfway up the right side of the image in the near distance is the Bank of Anderson, at the corner of South Main Street, which blocks the view of East Benson Street's (south side) section of the square. McFalls Pharmacy is on the right edge corner of this view on West Benson Street.

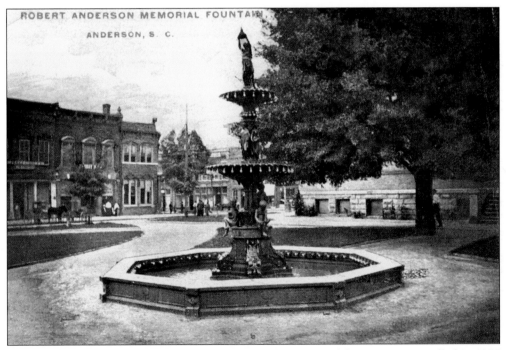

ROBERT ANDERSON MEMORIAL FOUNTAIN, [*c.* 1908.] The memorial fountain was installed in 1905 in honor of pioneer Gen. Robert Anderson, for whom the county was named. It was initially installed in a small landscaped area behind the courthouse. Then it was moved to Johnson Park in 1977. It was taken down and stored in 1993. In 2002 it was installed at the Anderson County Museum.

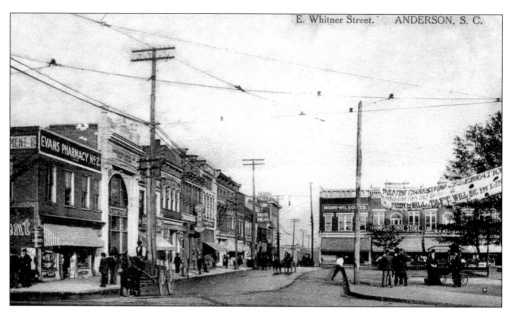

EAST WHITNER STREET, [c. 1913.] The view of East Whitner (Depot) Street shows the north side of the public square. The left corner begins with the Evans Pharmacy #2, the Anderson Banking and Trust Company (103), the Boston Shoe Store (105), and the W.H. Keese jewelry store (107). In the distance, the Moore-Wilson Company and the Thompson Shoe Store are on the corner of the Granite Row behind the courthouse. A banner for Ye Old Time Thanksgiving Celebration, when Teddy Roosevelt and Bill Taft were to be in town, is tied to the telephone pole on the right.

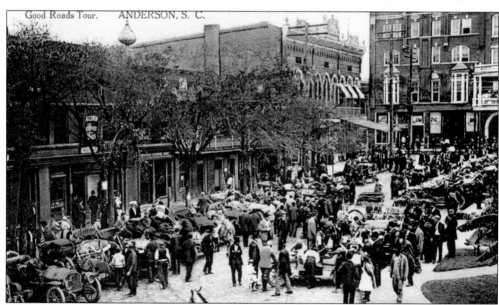

GOOD ROADS TOUR, [1909.] The 1909 *New York Herald* and *Atlanta Journal* Good Roads Tour went through Anderson and was organized to show that cars could drive safely from New York to Florida. A 1910 and a 1911 tour followed. In 1911 Bob King promoted the event and the city raised $1,000 for a gold and silver trophy cup that went to a winner. The Brick Range was behind the row of cars on the left center.

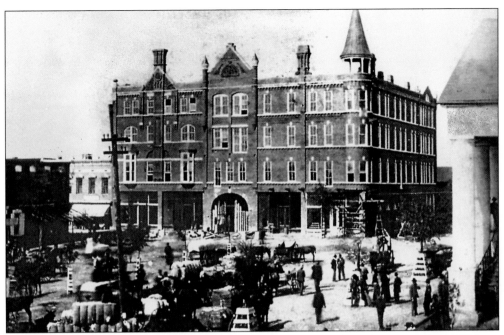

[HOTEL CHIQUOLA, 1888.] The elegant Chiquola Hotel was erected on the corner of West Whitner and North Main Streets. This $60,000 hotel was dedicated with a fashionable ball on New Year's Eve 1888. Guests included J.P. Richardson, governor of South Carolina. The ground floor had independent retailers, such as Evans Pharmacy. The hotel was entered by elevator from the lobby at 215 West Whitner Street. The hotel still stands.

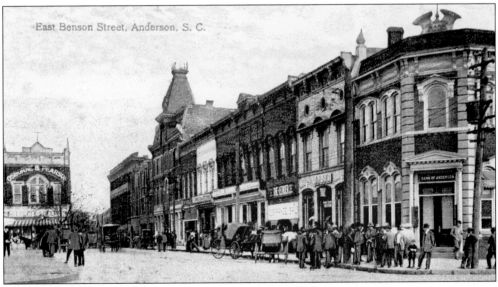

EAST BENSON STREET, [c. 1910.] The south side of the public square has the Bank of Anderson at the corner, 202 South Main Street, on the right. The next stores on Benson Street were Orr and Gray (104), Leader Dry Goods (106), Lesser and Company (108-110), C.S. Minor 5 and 10 (112), Morrow-Bass (114-116), and the Masonic Hall (118). The Osborne and Pearson Store was on the southeast corner of the Granite Row behind the courthouse.

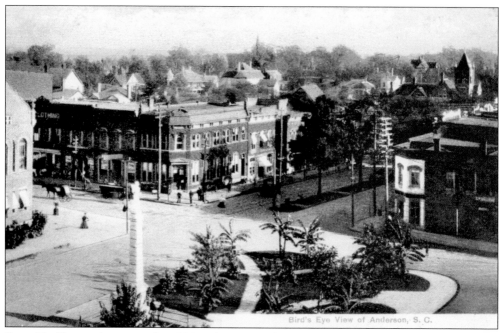

BIRDS-EYE-VIEW OF ANDERSON, [c. 1908.] This postcard view, taken from the Hotel Chiquola, shows the Confederate Monument and park in the lower center, and behind it, the Bank of Anderson is on the southeast corner of East Benson and South Main Streets. The McFalls Pharmacy is on the west corner. A distant view of City Hall is in the upper right background.

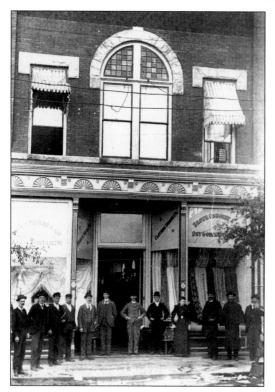

[BROWN, OSBORNE AND COMPANY, c. 1888.] This early dry goods retailer, Brown, Osborne and Company, c. 1888, shows the exterior decoration that would be appealing to the customers of that era. The first elevator in Anderson was in this building. This corner store was located at 115 Granite Row (east side) and East Benson Street. It was behind the courthouse in the back section of the public square.

22

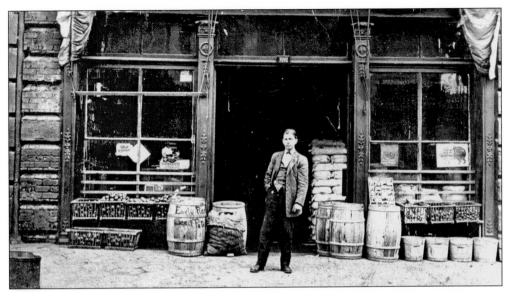

[PRUITT'S GROCERY STORE, *c.* 1912.] This postcard exterior view of J.A. Pruitt's Grocery Store at 217 North Main Street shows a casual display of barrels, baskets, bags, and containers of vegetables and fruits on the street. This store was listed in the 1905, 1910, and 1911 Anderson City Directory and shown on the 1911 Sanborn Insurance Company's Anderson fire maps.

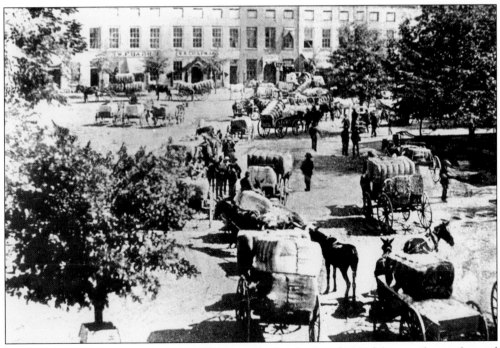

[THE GRANITE ROW (EAST SIDE), 1890.] The east side Granite Row, behind the courthouse, housed W.F. Barr and W.A. Chapman stores. Other retailers were Sullivan Store (on the north corner), Wilson and Reed, A.B. Towers, and Wilhite and Wilhite's Drug Store. The Bleckley Building, which housed the dry goods store of Brown, Osborne and Company, was on the south corner. The lot in front was used to park wagons.

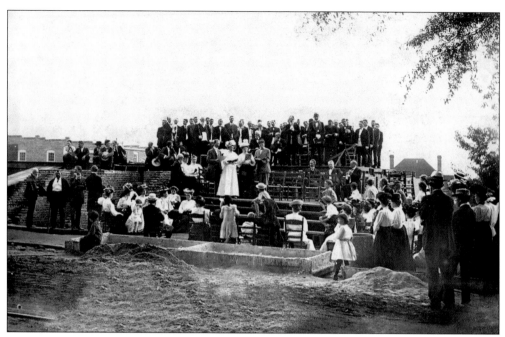

[LAYING OF THE LIBRARY'S CORNER STONE, 1907.] Lawyer J.N. Brown gave the county a lot and $5,000 and helped obtain a Carnegie Grant to build the library. The first lot had been selected and the foundation had been dug; however, it was abandoned after Mr. Brown gave his donation and this lot on North Main Street. Mr. Brown, his wife, and daughter are sitting behind the choir in the view above. The building still stands.

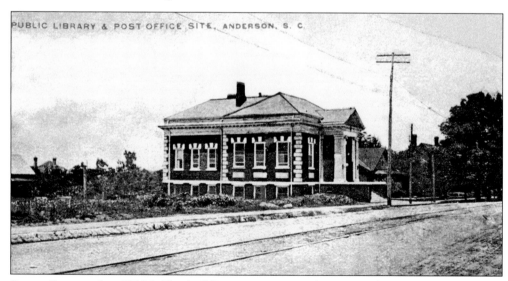

PUBLIC LIBRARY, [c. 1908.] The building committee with J.A. Brock as president selected the architectural plans submitted by J.H. Casey and obtained a Carnegie Grant of $17,500 with Mulkey and Davis Contractors. The trustees had $27,500 for the building, books, and supplies. The building on North Main Street opened on February 27, 1908 with 2,350 volumes. During the next two months 4,113 books had been borrowed. The 2002 library is located on McDuffie Street.

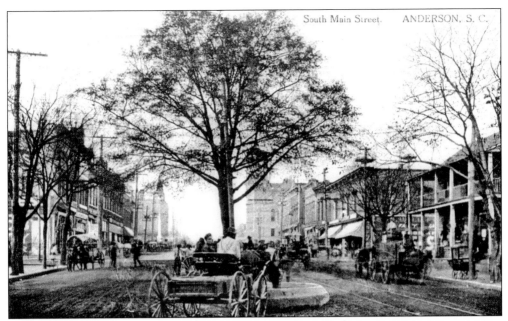

SOUTH MAIN STREET, [c. 1909.] This view shows the east side of the first block of South Main Street from Church Street looking north. On the extreme right is the front of the Garrison House, which was a meeting house with stores on the ground floor and rooms for guests on the second floor. Further up the street were J.K. Manos (215) and E.O. Burress (213) Stores. In the center of this scene, a wagon has stopped at the animal fountain so that the horse could have a drink of water.

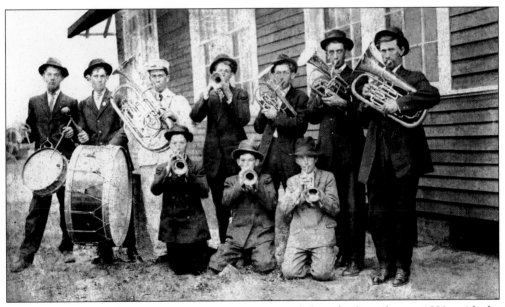

[TEN MAN BAND, 1900.] Anderson's Brass Concert Band dates back to the pre-1880s with the band going to regional competitions where they won prizes. They gave concerts in the Opera House, and they played at the dedications of public buildings, in the Memorial Day and Forth of July parades, and at sports events.

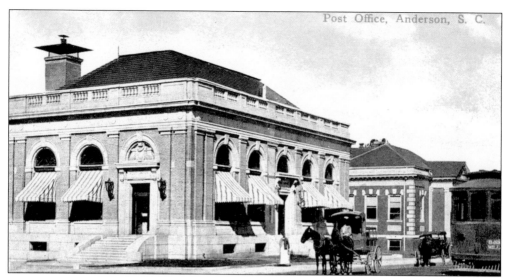

Post Office, Anderson, S. C.

POST OFFICE, [C. 1910.] The bids for the 401 North Main Street post office were opened in August 1908. J.K. Taylor was the supervising architect; W.D.T. Gentry was the contracting supervisor; and Gude and Company of Atlanta was the builder. The $70,000, 60-by-60 foot, brick and granite building opened in 1910 when John R. Cochran Jr. was postmaster. The post office in 1910 had eight city clerks, four railroad postal clerks, eight carriers, and eight RFD carriers. Its stamp sales totaled $26,029.

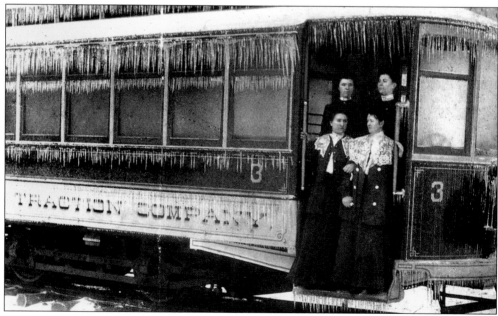

[DEDICATION OF THE STREETCAR, 1905.] The dedicating trial run was made on February 1, 1905 with J.A. Brock, president of the Anderson Traction Company, Miss Alberta Brock who started the car, and Superintendent Harris, who was the motorman. The Traction Company operated an Interurban line between Anderson and Belton in 1907. The courthouse acted as one station and the ground level Geer Hotel piazza in Belton became the other station. The streetcars were abandoned for busses in the 1930s.

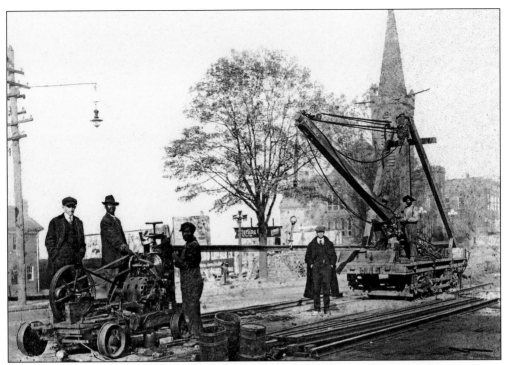

[LAYING STREETCAR TRACKS, 1904.] The streetcar tracks were laid in 1904 on North Main Street. The Central Presbyterian Church is seen in the background. The original schedule included lines from the public square to Riverside, Appleton, and Orr Mills and out Greenville Street. The River Street line passed by Buena Vista Park. The Traction Company developed the park to encourage weekend streetcar use. In 1910 the city began paving the street with bricks in cement.

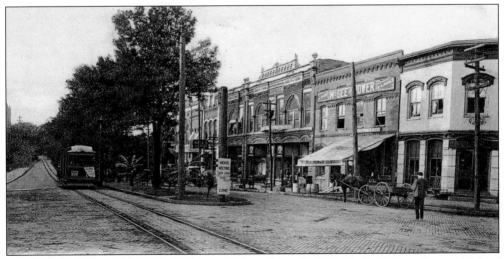

SOUTH MAIN STREET, [c. 1910.] This postcard view shows the Hill Block (200) on the west side of South Main Street looking south from Benson Street. McFalls Pharmacy (202) is on the corner, then McGee and Power Grocery (204–206), Sullivan Hardware (208–210), and Reese and Elliott dry goods (212). A landscaped median separates the two sides of the street with the streetcar tracks on the left side.

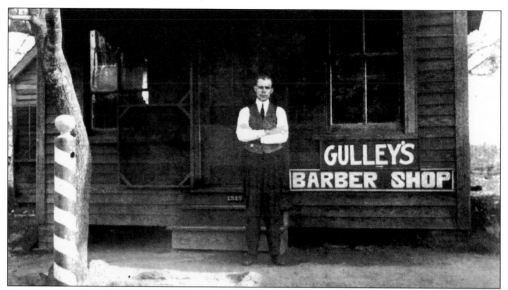

GULLEY'S BARBER SHOP, [c. 1915.] Jas. H. Gulley's barber shop was listed at 1917 South Main in the 1913–1914 Anderson City Directory. Gulley used this photographic postcard as a means of advertising his small shop. Willis A. Gulley was listed in the 1915–1916 city directory at this location, and they both also worked as barbers in other shops both before and after those dates.

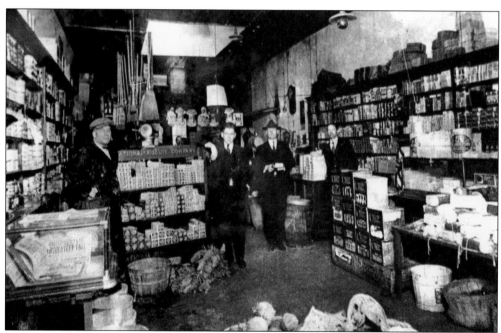

[R.C. MATTISON GROCERY STORE INTERIOR, c. 1925.] The R.C. Mattison and Company's Grocery Store was first situated at 125 East Whitner Street. Mattison had earlier purchased the stock owned by John and Josh Pruitt. Later the store moved into a ground-level unit in the Masonic Building on East Benson Street. It was listed in the 1925 and 1927 Anderson city directories. The men pictured are John Pruitt, Jesse Poore (clerk), G.B. Clark (salesman), and Raymond Mattison (owner).

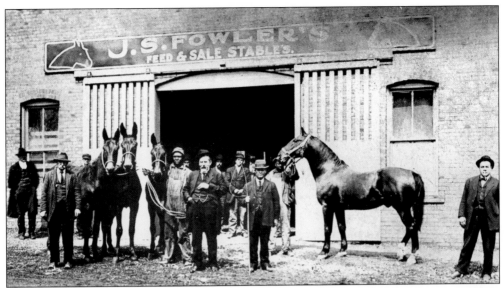

[FOWLER STABLES, *c.* 1908.] J.S. Fowler's Feed and Sales Stables was located at 134–138 West Whitner Street. It was listed in the 1905 Anderson city directory and shown on Sanborn Insurance Company's maps. This view includes Judge Fowler, the large man with a hat in the center, and Norman Cann standing on Fowler's left. In 1900 J.S. Fowler owned a plantation of 2,000 acres; employed 100 convict and hired laborers; and grew from 500 to 600 bales of cotton, 6,000 bushels of corn, and large crops of tobacco and oats.

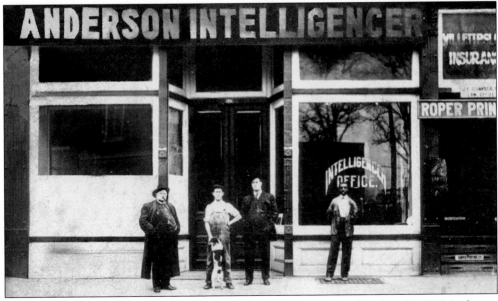

ANDERSON INTELLIGENCER, [*c.* 1913.] The *Anderson Intelligencer* was listed in the 1905 Anderson city directory with Fleetwood Clinkscales and Langston as editors and publishers. The paper was established in 1860 as a weekly and in 1907 as a semi-weekly. Their office was at 126 North Main Street and the Roper Printing at 124–1/2 North Main. In 1914 it became the Anderson *Daily Intelligencer* and continued until 1917. Other editors were J.C.C. Featherstone, Col. James A. Hoyt, and E.B. Murray.

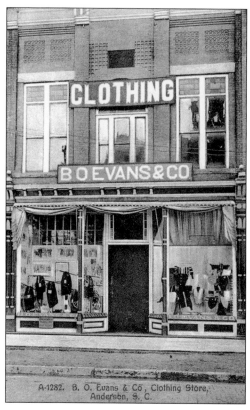

A-1282. B. O. Evans & Co, Clothing Store, Anderson, S. C.

B.O. EVANS & COMPANY, [C. 1909.] The B.O. Evans & Company clothing store, shown on the postcard at left, was located at 107 South Main in the Granite Row block in 1897, on the east side of the public square behind the courthouse. It was listed in Anderson's first city directory, in 1905, at that location.

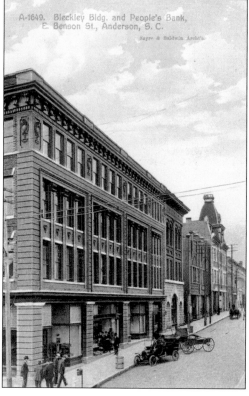

A-1649. Bleckley Bldg. and People's Bank, E. Benson St., Anderson, S. C.

Bayre & Baldwin Archt's.

BLECKLEY BUILDING AND PEOPLES BANK, [C. 1915.] The corner Bleckley Building at 130 East Benson Street concluded the block that was the south side of the square. The Peoples Bank (128) was incorporated in 1899. Adjacent stores were Breazeale Tailoring Company (124), Planters Supply Grocery (122), J.T. Jones Company (120), and the Masonic Building and Opera House (118) with its distinctive roof.

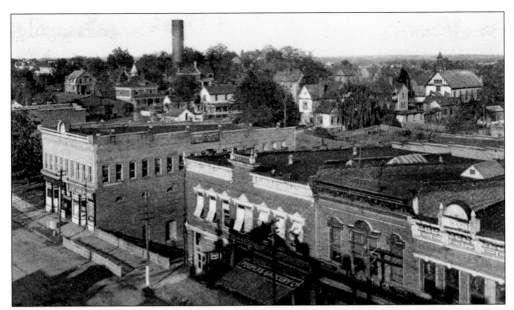

BIRD'S-EYE-VIEW, NORTHEAST, [c. 1910.] This postcard view shows the east side of the first block of North Main Street beginning with P.L. Barr Drugs (110), J.C. Wigington Dry Goods (112), Peoples Grocery (116), and J.K. Manos confectionery (118). The Blue Ridge Railroad cut, which was excavated for the train to travel below street level, is shown at the left center. At that time only the bridge is shown. Their depot was built in that cut over the tracks in 1913–1914.

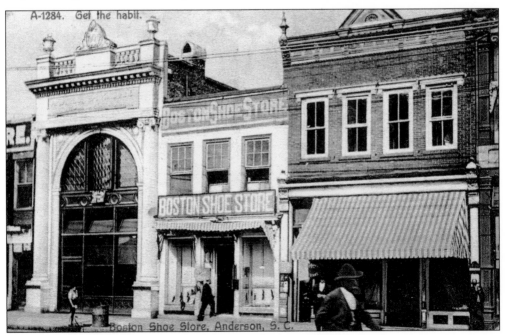

GET THE HABIT–BOSTON SHOE STORE, [c. 1913.] This postcard view is of East Whitner (Depot) Street, on the north side of the square across from the courthouse. On the left is the Anderson Banking and Trust Company (103), the Boston Shoe Store (105), and W.H. Keese Jewelry Store (107). They were listed in Anderson's city directory in 1905 and 1911.

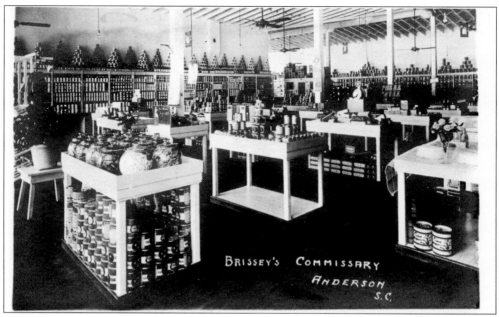

BRISSEY'S COMMISSARY, [*c.* 1922–1923.] Brissey's Commissary was at the corner of Fant and Orr Streets in 1922. This interior postcard view shows merchandise placed on small tables and on wall shelves. The W.L. Brissey store was listed in the 1925 and 1927 city directories.

[HILL BLOCK, *c.* 1900.] The Hill Block was the west side of the 200 block of South Main from Benson Street to Church Street. A farmer's alliance co-op store, where farmers could market their produce, was managed by Rufus S. Hill. The Alliance Store at 208–210 South Main Street became the Sullivan Hardware Company, which was later called the Sullivan building.

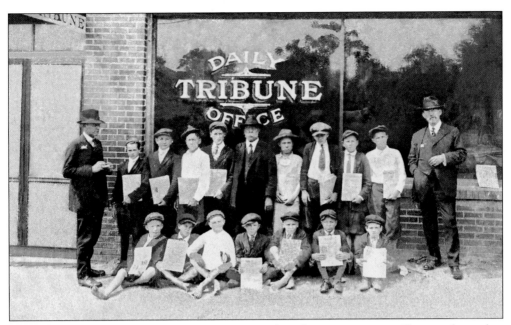

[DAILY TRIBUNE OFFICE, c. 1920.] Anderson's *Daily Tribune* newspaper office was located at 115–117 East Market Street. The picture shows the newspaper staff and carriers. This paper was established about 1916 with V.B. Cheshire as the editor and proprietor. The *Tribune* was listed in the 1920–1923 city directories.

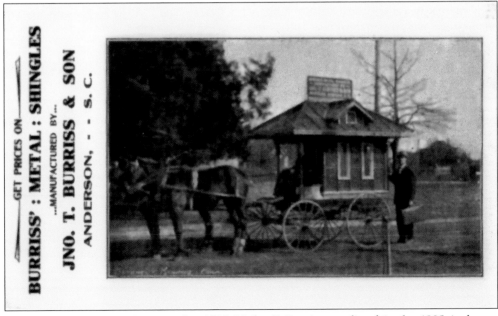

BURRISS METAL SHINGLE COMPANY, [c. 1909.] John T. Burriss was listed in the 1905 Anderson city directory as a roofing contractor. The advertising postcard above was used to solicit roofing jobs and the image was repeatedly used in the December 1909 issues of Anderson's *Daily Mail*. John T. Burriss and Son Company was listed in the 1909–1912 city directories as sheet metal contractors at 212–214 East Benson Street.

[CONFEDERATE VETERANS AND DAUGHTERS REUNION, 1910.] Anderson County Confederate Veterans assembled at Anderson's Buena Vista Park pavilion on June 3, 1910, the anniversary of the birth of Jefferson Davis. The annual reunions were entertained by the United Daughters of the Confederacy. The veterans included E.T. Gambrell, A. Pickens, and J.L.C. Jones. Daughters of the honored veterans accompanied their fathers and included N. Cochran, C. Patrick, and P.R. Fant.

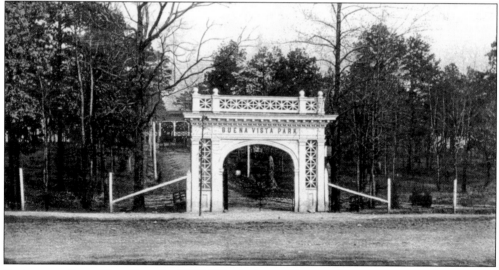

ENTRANCE TO BUENA VISTA PARK, [c. 1908.] The Anderson Traction Company streetcar lines carried workers to and from the mills during the week. However, the trolleys were not used on weekends so the company built the Buena Vista Park on East River Street. The park had swimming pools, a theater, baseball field, zoo, restaurant, dance pavilion, and other entertainment. The trolleys were then used to travel to the park for various entertainments.

CONFEDERATE MONUMENT, [c. 1908.] On Decoration Day 1886, the Confederate Memorial Association was organized to erect a Confederate monument. Miss Lenora C. Hubbard was the first president of the Ladies Memorial Association of Anderson County. The monument committee raised $2,500 and commissioned Oscar Hammond of Greenville to sculpt the Confederate soldier, which was 7 feet and 6 inches tall, using Tennessee gray marble. The 35-foot monument had a triple base. It was unveiled on January 18, 1902 with 150 veterans in attendance.

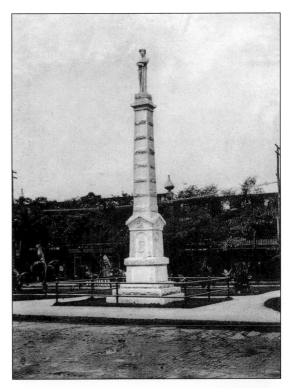

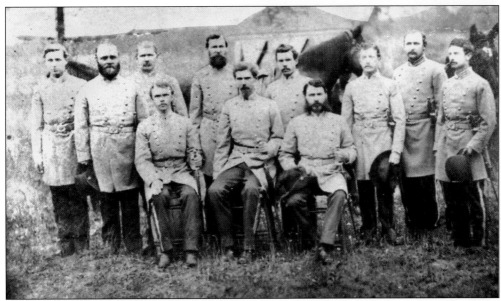

[ANDERSON COUNTY CONFEDERATE SOLDIERS, c. 1870.] This portrait of Anderson County Confederate Veterans taken at a reunion in Anderson in 1870 depicts Brig. Gen. W.W. Humphreys (Fourth South Carolina Volunteer Regiment) and his staff. From left to right, they are (standing) T.C. Ligon, J. Pinckney "Pink" Reed, Douglas Sloan, ? Moorhead, S. Todd, S.H. Prevost, Reece Fant, and J.J. Fretwell; (seated) Edwards Murray, Gen. Wm. Wirt Humphreys, and Col. P. Keys McCully of the Second South Carolina Regiment of Rifles.

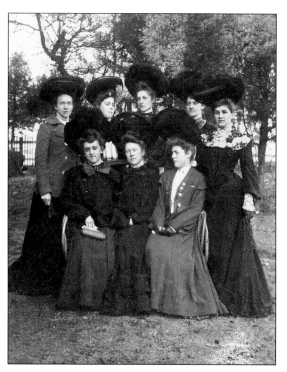

[CHARTER MEMBERS OF THE PALMETTO CHAPTER OF THE UNITED DAUGHTERS OF THE CONFEDERACY, 1904.] The Charter Members of the Palmetto Chapter of the United Daughters of the Confederacy in 1904 were Misses Brazille, Taylor, Brown, Lilson, Bee, Burries, Brown, and Todd. They entertained the veterans at the annual reunions at Buena Vista Park.

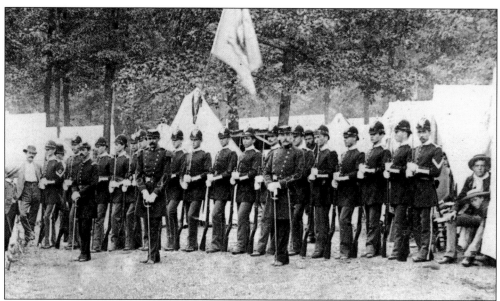

[PALMETTO RIFLEMEN, 1888.] The Palmetto Riflemen Company was established in 1861 as part of the Fourth South Carolina Regiment, which contained many Anderson County men. It had 145 men initially; however, only 39 remained in the company when Lee surrendered in 1865. They continued encampments after the Reconstruction era (1865–1877) with the one pictured above at Camp Anderson in Greenville in July 1888. At that time T.F. Hill was captain. In 1905 the Palmetto Rifles met every Wednesday night at the armory at 132–1/2 East Whitner Street. P.K. McCully Jr. was captain.

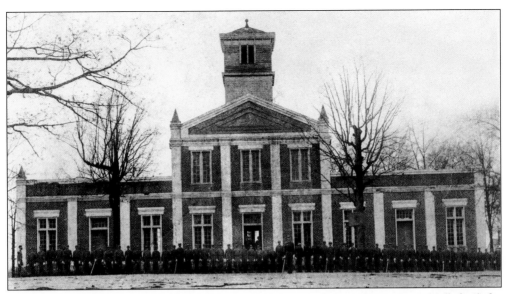

[PATRICK MILITARY ACADEMY, c. 1893.] This structure on South Main Street was initially built for the Johnson Female Academy in 1853. At the end of the Civil War it was used to store part of the Confederate Treasury and then became headquarters for Union troops garrisoned in Anderson during the Reconstruction era. Next it became W.J. Ligon's Carolina Collegiate Institute for boys in 1866. In 1889 Col. John B. Patrick move his Patrick Military Academy from Greenville to this Anderson campus. After the academy closed the building was razed.

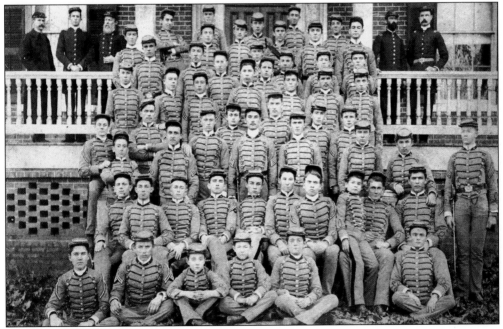

[CADETS, PATRICK MILITARY ACADEMY, c. 1896.] This picture of the Patrick Military Academy cadets was taken after Col. John N. Patrick moved his military academy from Greenville to the Anderson campus in 1889. He was the president of the academy. In 1896 it was considered one of the best schools in Anderson. It closed in 1899.

[RED SHIRT REUNION, ANDERSON, 1909.] Wade Hampton III served in the South Carolina Senate from 1858 to 1862. He organized and commanded a cavalry unit known as "Hampton's Legion" and rose from general of cavalry to commander of cavalry of the Army of Northern Virginia. In 1876, he ran for South Carolina governor as a Conservative Democrat against the Reconstruction-era incumbent Republican D.H. Chamberlain. Federal troops and out-of-state republicans tried to prevent a Democrat from winning, but men, including Civil War veterans from Anderson

[PAGEANT, ANDERSON COUNTY CENTENNIAL, 1928.] Centennial parades and events celebrated the 100th anniversary of the city and county. A three-day historical pageant was presented at Memorial Field on South McDuffie Street from June 13 to 15, 1928. A cast of about 1,500 began the presentations with scenes featuring the Indian era, Civil War topics, and 1900-era subjects.

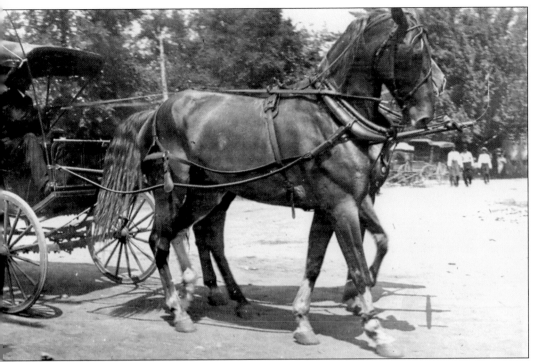

County, formed night-riding units to support Hampton's bid. Because of armed skirmishes, the Democrat supporters wore red-dyed shirts to distinguish themselves and prevent accidental fighting between supporters. Red Shirt Day was held on August 25 during the first decade of the 20th Century. These reunions of Wade Hampton's Red Shirt veterans of 1876 met at Buena Vista Park. Confederate veterans and members of the Red Shirts, like J.L.C. Jones, would march in parades to the park, and the reunion events there were the highlight of their year.

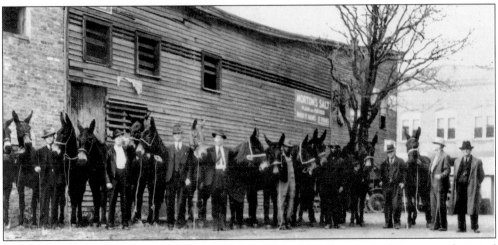

[E. McGee Mule Stable, c. 1920s.] The McGee Mule Sales Barn in Anderson was the retail outlet for the McGee farm near Starr. During the 1920s a McGee representative would buy 50 or more wild mules in Missouri, bring them to their farm, and train them for farm work. The mules were sold in the fall at their Anderson Barn. The McGee salesmen from left to right, are Willis McGee, Prue W. McGee, Mr. McNinch, and Elias McGee. Their stable was located on West Church Street.

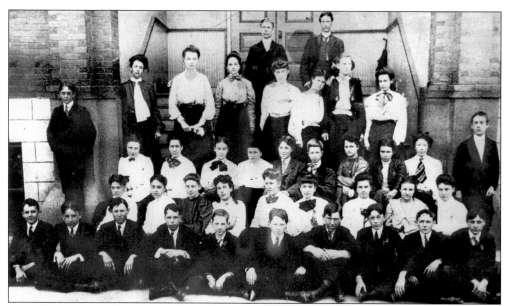

[FANT STREET HIGH SCHOOL STUDENTS, c. 1905.] In 1905 John Linley was the principal and the three teachers were E.C. McCants, A.W. Fogle, and B. Wicker. Grammar School #2 at Anderson Mills had B.C. Cromer as principal and three teachers. Brogan Mill School had A. Farmer as principal and one teacher. Orr Mill School had M. O'Neal as principal and two teachers. Riverside Mill School had N. Harris as principal and one teacher.

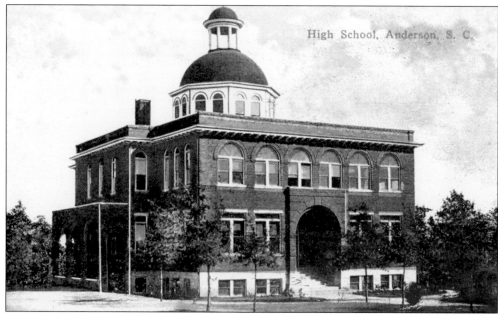

FANT STREET SCHOOL, [c. 1908.] Anderson High School at 520 North Fant Street opened in 1904 and cost $12,000. After a period of time this building was too crowded to successfully teach the high school students. The superintendent transferred the high school teachers and students to the older West Market Street school and the building at Fant Street became an elementary school. In 1918 it housed grades 1 through 7 with 9 teachers and 362 students.

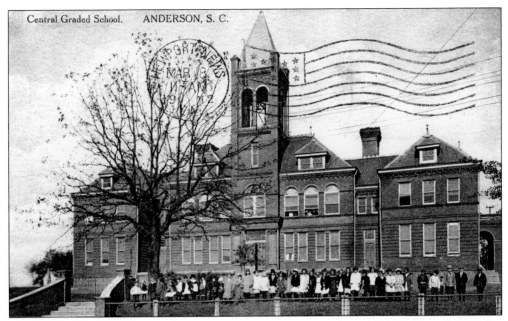

CENTRAL GRADED SCHOOL, [*c.* 1912.] The legislative act of 1894 established the Anderson City School System. The Central Graded School (Grammar School #1) on 414 West Market Street opened in January 1896 with 380 students. Many felt that the erection of so large a building was a "useless expenditure of the people's money." Professor Moncrief of Clemson College was the first superintendent. The 1896 teachers were L.C. Hubbard, M. Evans, Mrs. S.C. Baker, M. Russell, Mr. Adkins, F. Watkins, and Ms. Stokes.

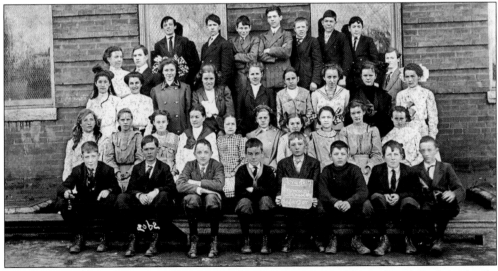

[ANDERSON GRAMMAR SCHOOL SEVENTH GRADE CLASS, 1900.] In 1900 Anderson had 4 schools, 18 teachers (who each made an average salary of $159), and 764 students. By 1901 Anderson's school teachers had grown to 23 and their salary had increased to $289. The city's student body had expanded to 1,000 students. Grammar School #1 in 1905 had E.M. McCown as principal and the teachers were N. Hubbard, E. Gordon, A.B. Brown, M. Russell, M. Ligon, E. Divver, N. McCoy, and M. Chapman.

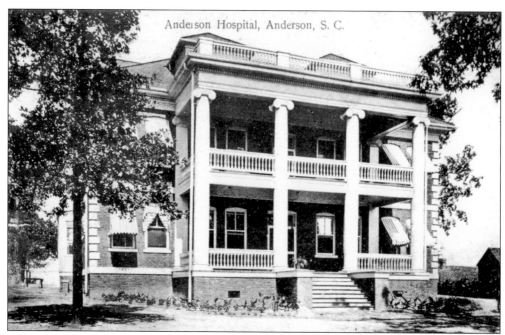

Anderson Hospital, Anderson, S. C.

ANDERSON HOSPITAL, [c. 1909.] The first hospital building was erected on Fant Street in 1907 and burned down soon after. Anderson Hospital, pictured on the postcard view above, opened on April 20, 1908. J.H. Casey was the architect. The structure cost $26,000, which was raised by public conscription. Later, a nurse's training school opened with the students obtaining practical experience in the hospital.

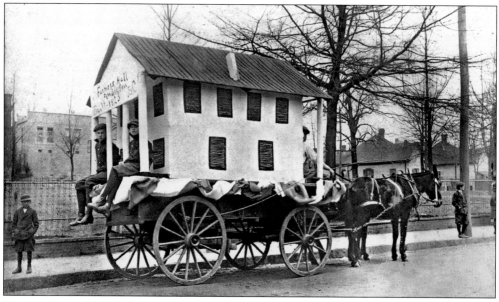

[PARADE FLOAT, 1920.] The Pendleton Farmers Society Hall has been a significant structure for the citizens of Anderson County. In 1920 the float above was created for a farm youth parade in Anderson. Robert Day and Jay Garvin are seated in the back of the horse-drawn float, which is parked in front of the West Market Street School in Anderson.

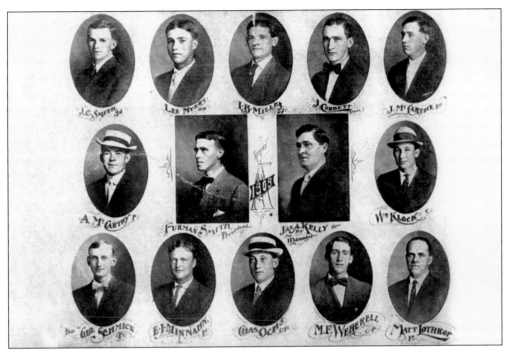

ANDERSON BASEBALL TEAM, 1909. Anderson's 1909 baseball team was in the Carolina Association league and played in Buena Vista Park. The league consisted of teams from Anderson, Charlotte, Greensboro, Greenville, and Spartanburg. Furman Smith was the president of the Anderson team and J. A. Kelly was the manager in 1909, which finished in second place with a record of 63 wins and 48 losses behind first place Greensboro.

YOUNG MEN'S CHRISTIAN ASSOCIATION, [c. 1911.] Anderson's Young Men's Christian Association was organized on March 15, 1909 with J.L. Sherard as president. They met on Thursday evenings in Evans Hall at 315 1/2 North Main Street. By 1911 the YMCA had 221 members and moved to 505 South Main Street. Their facilities had a gym with shower, locker rooms, and game rooms.

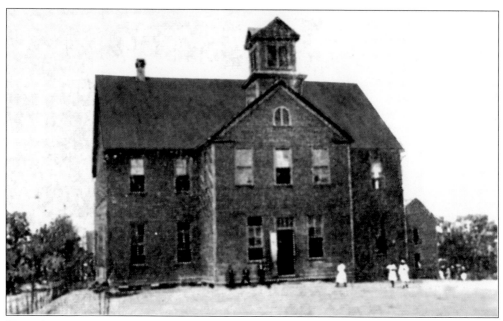

[REED STREET HIGH SCHOOL, c. 1918.] In the late 1890s the Greeley Institute on McDuffie Street taught African-American students. Two black schools were being used in 1900 and Greeley had 5 teachers and 583 students. A brick school was constructed in 1901 at a cost of $3,000 on the corner of South Towers and Reed Streets. The 1905 city directory called it Grammar School #4, and Mr. M.H. Gassaway was principal with 9 teachers.

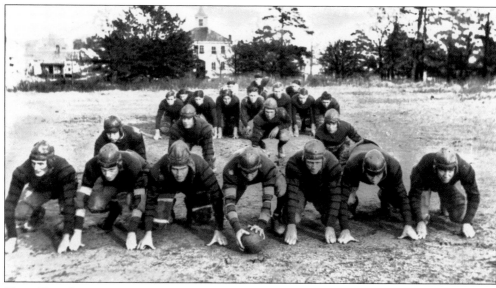

[BOYS HIGH SCHOOL FOOTBALL TEAM, 1922.] The Boys High School Yellow Jacket football team only lost two football games in 1922. Their seven winning games were against Due West, Fountain Inn, Seneca, Walhalla, Abbeville, Laurens, and Greenwood, while losing to Thornwell and Honea Path. The coach was Dode Phillips. Team members included F. Dean (captain), H.G. Anderson, A. Skelton, J. Ellis, F. Brown, L. Glenn, E. Wall, B. Ligon, J. Moseley, C. Fisher, and C. Hogrefe. B. McCorkle and B. Barton were assistant coaches.

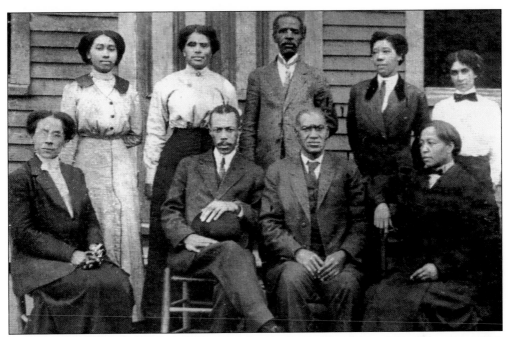

[FACULTY, REED STREET SCHOOL, 1914.] The faculty of the Reed Street African-American High School included Prof. M.H. Gassaway as principal and teachers Mrs. Gassaway, Mr. Todd, Mrs. Todd, A. Anderson, I. Watson, Mr. Rhodes, M. Gassaway, Mrs. Moore, and M.G. Brown. Black teachers' average salaries for 1900 were $108 while salaries in 1901 were $113. In 1918 the Reed Street School had an enrollment of 286 students and 11 teachers in the 7 elementary grades and a 3-year high school program.

[SOUTH FANT STREET SCHOOL, C. 1918.] The 1127 South Fant Street African American School had Mary J. M. Earle as the principal in 1915 with seven teachers. She continued as principal through 1917 with 8 teachers. The 1918 survey found the South Fant School had 363 students and 9 teachers. In 1928 the enrollment was 1,251 with 37 teachers.

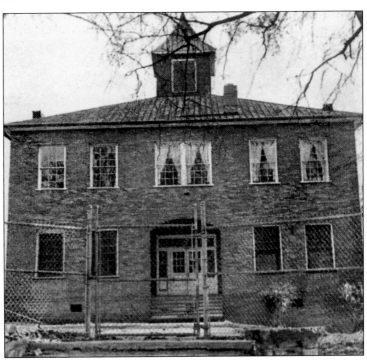

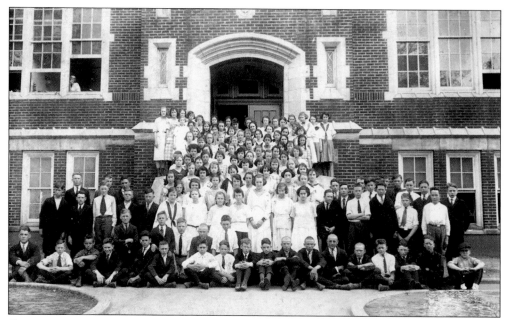

[ANDERSON HIGH SCHOOL STUDENTS, 1923.] This high school building was constructed in 1917 at the corner of Greenville and McDuffie Streets. In 1922 T.L. Hanna was the principal with 18 teachers. It became an all-girls school in 1923. The boys were moved to a new boys high school, which was in use until the 1950s. The girls high school was torn down in 1970.

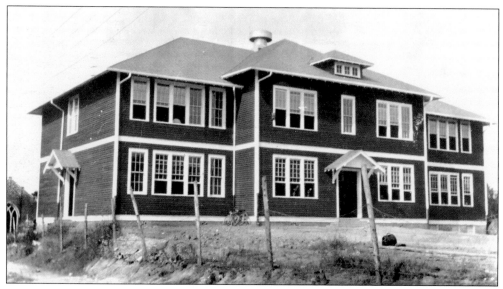

[ROSENWALD'S REED STREET SCHOOL, 1922.] The Julius Rosenwald Fund was established to promote the building of Southern black schoolhouses. The school board asked the fund to help replace the old Reed Street School. They accepted and Rosenwald contributed $1,600, white gifts totaled $11,400, and the state contributed $42,000 to erect this 12-teacher black schoolhouse. From 1914 to 1932 the Rosenwald Fund assisted in the building of 4,977 mainly rural black schools in the South. The fund assisted 481 South Carolina schools with gifts totaling $463,600, or 15.68 percent of each school's costs.

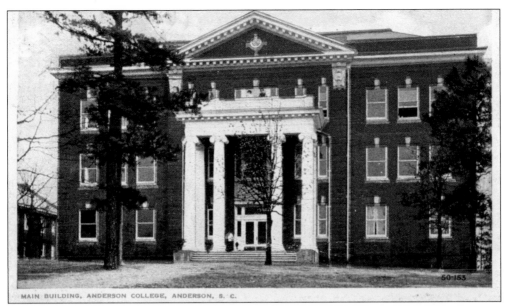

MAIN BUILDING, ANDERSON COLLEGE, ANDERSON, S. C.

MAIN BUILDING ANDERSON COLLEGE, [1913.] Anderson College opened in 1911 as a South Carolina Baptist Convention College for women. Dr. J.A. Chambliss was its first president. The main three-story building shown above had classrooms, an auditorium, and a dining hall. A brick dormitory was on either side of the main building. It enrolled 231 students in 1918. It was a senior college for 19 years, and a junior college from 1930 to the 1990s, when it returned to a senior college.

BOYS HIGH SCHOOL, [c. 1927.] The boys high school at the corner of McDuffie and Broyles Streets had R.H. Jones as principal and 10 teachers in 1927. It was renamed McDuffie High School in the 1960s. Gunter's 1918 Anderson County school survey listed the city's schools as follows: West Market, 562 students and 17 teachers; Glenn, 754 students and 11 teachers; North Fant, 362 students and 9 teachers; Kennedy, 401 students and 11 teachers; Southside, 325 students and 6 teachers; East Whitner, 187 students and 4 teachers; and North Anderson, 51 students and 1 teacher. The total number of students was 2,670, and there were 10 high school and 51 elementary school teachers.

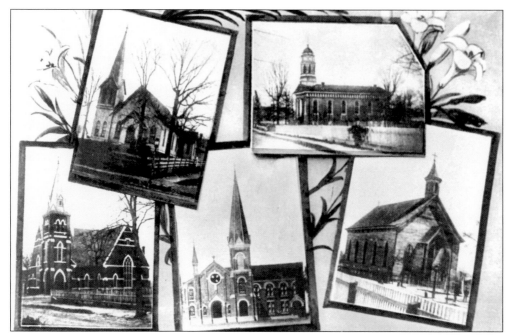

[ANDERSON CHURCHES, C. 1889.] This multi-view of Anderson churches documents the 1889 structures that came before the 1910-style brick facades that are shown later in this chapter. Starting in the upper left, they are the 1860s frame Episcopal Church, the 1879 brick Presbyterian Church, the 1888 brick Methodist Church, the 1889 brick Baptist Church, and the 1881 frame Catholic building on North McDuffie Street.

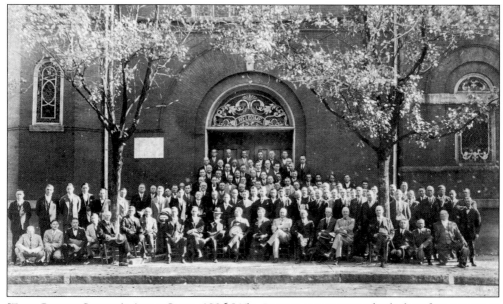

[FIRST BAPTIST CHURCH'S ADULT CLASS, 1926.] The Baptist congregation built their first sanctuary in 1858 on Manning Street. Additions were made in 1890, as shown in the top multi-view, and in 1908. The minister in 1905 was Rev. J.D. Chapman. In 1909, the membership was 785 and Rev. J.F. Vines was the pastor. The Baptist Church's adult class posed for this group picture in 1926.

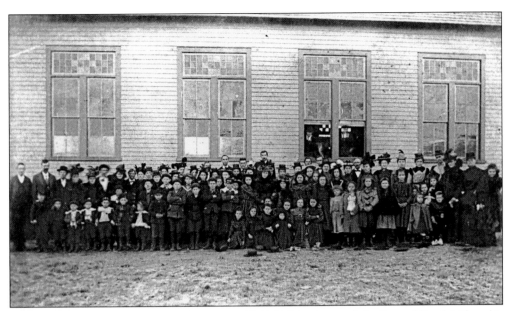

[SECOND BAPTIST CHURCH'S SUNDAY SCHOOL, C. 1910.] This picture of the Second Baptist Church's Sunday School was at the Anderson Mills' village. Rev. William Brown was the pastor in 1905. Their membership was 314 in 1909 when Rev. H.C. Martin was the minister. Rev. E.J. Jones was the pastor in 1922. It is now called Garner Memorial Baptist Church.

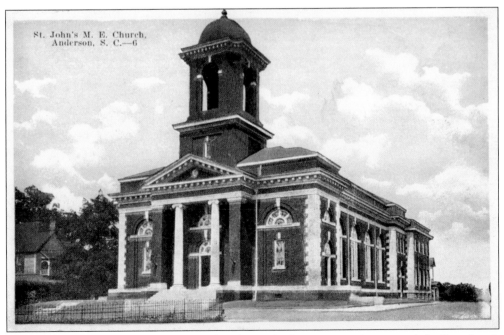

ST. JOHN METHODIST E. CHURCH, [C. 1914.] The Methodist congregation erected the first church building in this town and was followed by other sanctuaries built at different locations. The 1888 edifice on McDuffie and River Streets had poor ground conditions and was declared unsafe and razed. In 1905 Rev. M.B. Kelly was the pastor. The 1912 structure, shown above, was built on the same lot. Additions have been made over the years.

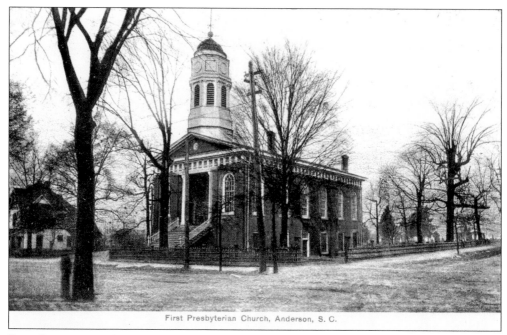

First Presbyterian Church, Anderson, S. C.

FIRST PRESBYTERIAN CHURCH, [*c*. 1908.] The first small frame structure facing Tolly Street was erected in 1837 with a membership of 13. A larger building was erected facing Whitner Street in 1839. The cornerstone to their brick sanctuary shown above was laid in 1879. Rev. S.J. Cartledge was the pastor in 1905.

EPISCOPAL CHURCH, [*c*. 1908.] The initial frame Grace Episcopal Church was erected in 1860. The first service in the brick and stone structure was Easter Sunday, 1904. The sanctuary was designed and built on the same site under the direction of Christopher Sayre, architect. Rev. R.C. Jeter was the minister in 1905.

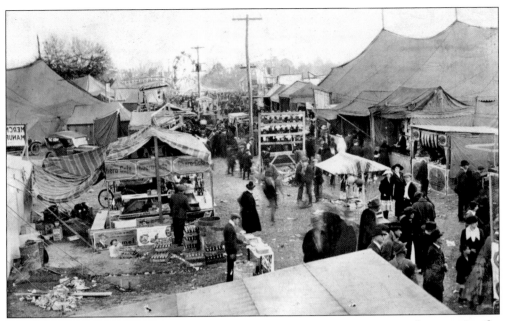

[ANDERSON COUNTY FAIR, 1920.] The annual Anderson County Fair was a popular attraction for the farmers and residents of that era. The Rubin and Cherry Shows brought a wide selection of booths with games of chance and skill and special snacks along the midway. This traveling troupe visited several county fairs in South Carolina. Rides such as merry-go-rounds, ferris wheels, and other entertainment for children were popular. Large tents were used for shows and events.

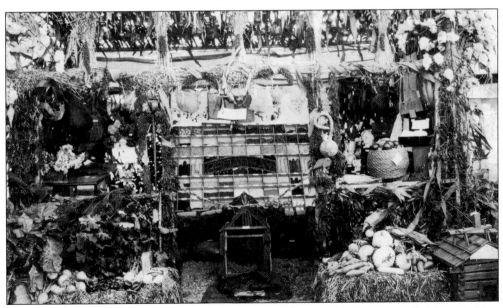

[EXHIBIT, ANDERSON COUNTY FAIR, 1920.] The Anderson County Fair Committee began organizing the November fair in May. The list of premiums was published in May so that the farmers could grow controlled plots of produce in relation to the specific rules of each premium. The Broadway Community exhibit above shows some of the selected specimens raised by those farmers. Prizes were awarded to the best examples in each category.

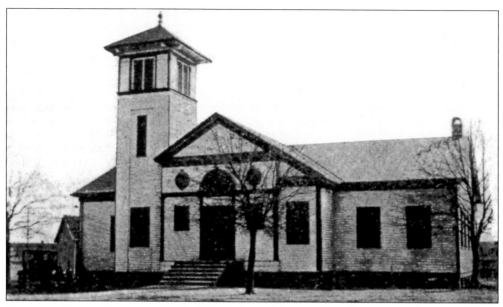

[OAKWOOD BAPTIST CHURCH, c. 1915.] The Oakwood Baptist Church was located in the western section of the city between Brogan Mills and the Cox Mill Village, which became the Equinox Mill Village c. 1915 after the mill was sold. In 1909 the minister was Rev. H.C. Martin, and the church had a membership of 163. The Rev. L.M. Smith was listed as their pastor in the 1915–1916 city directory. In 1920 the Oakwood Baptist Church's pastor was Rev. E.C. White.

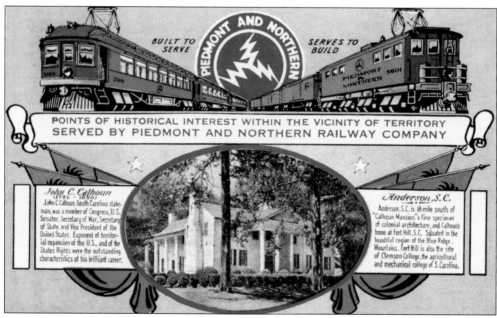

PIEDMONT AND NORTHERN RAILROAD COMPANY, [c. 1920s.] After 1912 the Piedmont and Northern Railway Company built a line connecting most of the county's mill towns with the Piedmont region, extending west to Spartanburg and south to Greenwood. This Inter-Urban line used electric power, which ran most of the mills, rather than wood or coal, which traditional trains used. The line used the lighter streetcar-type coaches. Their Anderson depot was on Main Street.

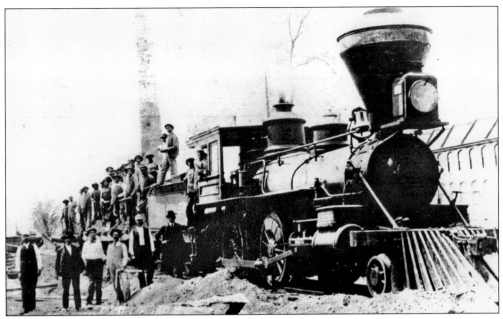

[BLUE RIDGE RAILROAD, *c.* **1903.**] The Blue Ridge Railroad Company was incorporated in 1852. Trains began using a cut below street level, just north of the square, in 1856, and the tracks were laid north to Pendleton and then to West Union. The 1903 view above shows their early wood-burning locomotives with construction workers standing on the flat car after unloading the building supplies for the Brogan Mills. This line built a new depot in 1914 on North Main Street.

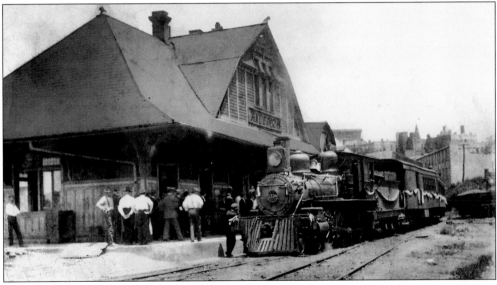

VIEW OF UNION STATION, ANDERSON, [**1908.**] This Union Station was completed in the spring of 1902 at the end of West Earle Street and served several lines. It was used by the Blue Ridge Railroad and the Savannah Valley Railroad [1885]. The Charleston and Western Carolina Railroad had a branch line to Anderson starting in 1853. This 1908 view shows the funeral train carrying George Keith's body back to Walhalla after he was killed while flagging the Manning Street crossing on May 25, 1908.

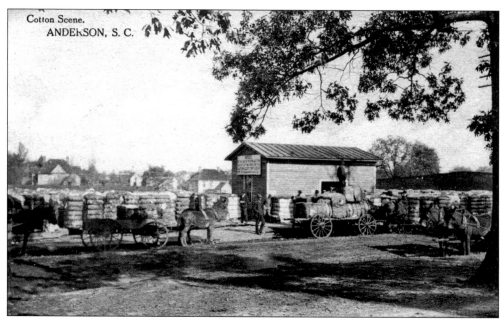

COTTON SCENE.
ANDERSON, S. C.

COTTON SCENE, [c. 1908.] This cotton scene is a typical one for this era at every cotton gin. The farmers hauled their annual crop to the gin that often stood beside the railroad tracks. In this image the tracks are hidden behind the cotton bales and building. In 1901 Anderson city marketed about 35,000 bales of cotton.

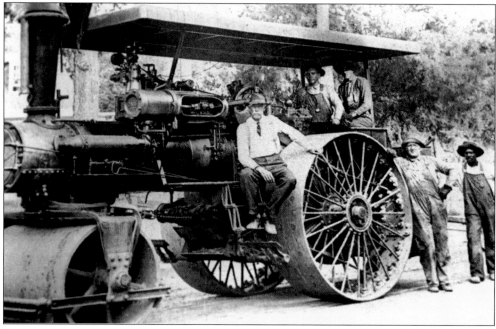

[STREET WORKERS, c. 1920s.] As wagons gave way to automobiles the streets needed to be maintained, potholes filled, and paved in more permanent materials. Each city began to obtain heavy earth-shaping equipment. Then crews of street workers were hired to repair and maintain these streets. The image above shows such a team.

[MISS COTTON PRINCESS, ELIZABETH BIGBY, 1932, WALLACE STUDIO.] A promotional project to encourage the wearing of cotton clothing began in Anderson in 1931. Mrs. Elizabeth (George F.) Bigby was the chairwoman of the organization that had women from all cotton-producing states join in an effort to promote cotton use. Elizabeth, Mrs. Bigby's daughter, was princess in 1932. She wears a crown of cotton and holds a cotton bouquet.

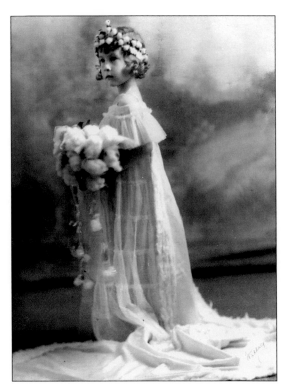

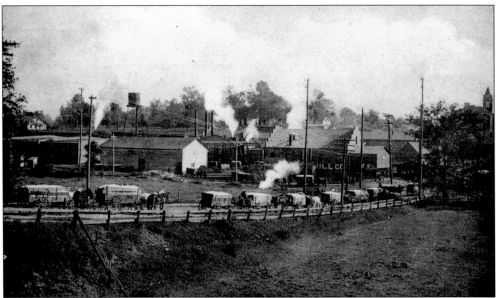

FARMERS OIL MILL GINNERY, [c. 1908.] The Farmers Oil Mill was at 512 West Market Street with J.R. Vandiver serving as the president and J.T. Bolt as the manager. The site was located on the Sanborn Insurance Company's 1911 Anderson map, which was near the Charleston and Western Railroad tracks. The farmers' wagons with their cotton harvest are lined up to have their crops ginned. In the upper right of this view is Anderson City Hall. The Farmer's Oil Mill Ginnery burned down in 1914. Postcard scenes of cotton gins were found in every town.

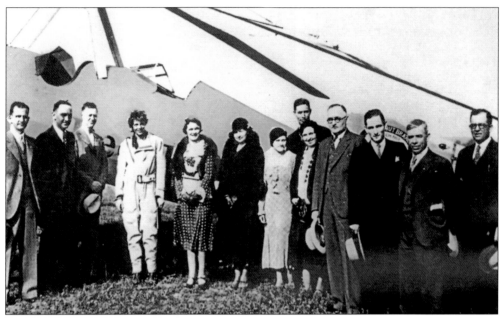

[AMELIA EARHART AT ANDERSON'S AIRPORT, 1931.] Amelia Earhart flew into Anderson's airport in her Beechcraft Autogyro on November 14, 1931 and attracted over 1,000 spectators. Mayor G.T. McGregor and other city leaders met her at the airport. A year later she flew across the Atlantic Ocean alone from Newfoundland to Ireland and later she flew from Honolulu to the United States mainland. She later vanished on a 1937 flight over the Pacific Ocean to New Guinea.

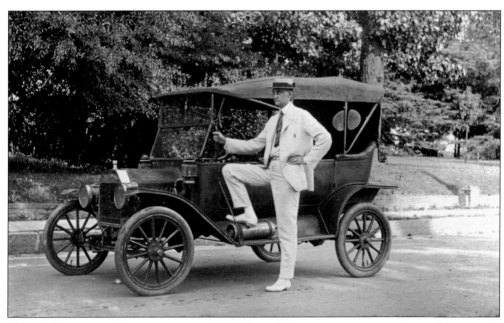

[JAMES L. DAVENPORT, PHOTOGRAPHER, c. 1912.] James L. Davenport was operating a photographic studio in Piedmont from 1900 to 1904. Later, Davenport visited Anderson and made studio and postcard photographs of various subjects. The photographic postcard above, c. 1912, shows Davenport standing by his car.

Two

ANDERSON COTTON MILLS

The city's first cotton mill was in production in 1890 using steam power. In 1894 Anderson's first hydro-electrical power plant at High Shoals began serving the city. Anderson Cotton Mill converted to electricity and became the first electric cotton mill in the United States. The 1906 totals for the five city mills in this chapter are 188,760 spindles, 4,716 looms, and 34,638 bales of cotton processed annually with a produce value of $3,534,817. In 1906 Anderson County mills had a total assessed value of $4,088,931 and a total taxes charged of $52,130. The city mills payroll was $683,342 for 2,575 operatives who lived in mill villages with a population of 6,300. In 1905 the city had four mill schools with four principals and seven other teachers.

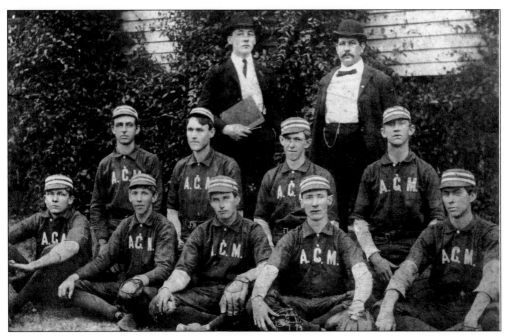

ANDERSON COTTON MILL'S BASEBALL TEAM, 1900. The Anderson Cotton Mill's baseball team was active as early as the 1890s with the team playing regularly scheduled games with mills at Belton, Honea Path, Pelzer, Piedmont, and Williamston. The 1895 Anderson Cotton Mill team played in a tournament against the Newberry Cotton Mill team near Spartanburg on September 4, 1895 with Anderson winning the game 2 to 1. From 1898 to 1900 the Anderson team played in an independent league including Pelzer, Piedmont, Greenwood, Abbeville, Union, and Asheville.

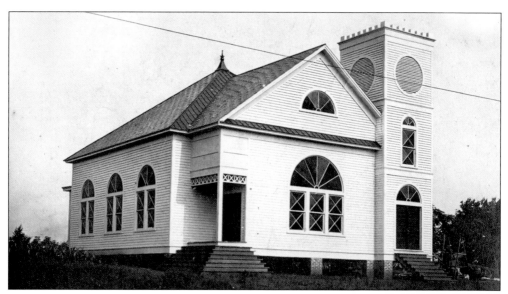

[RIVERSIDE BAPTIST CHURCH, c. 1910.] The Riverside Mill's church was the Riverside Baptist Church, which in 1909 had 98 members and shared Rev. M.M. McCuen with the Concord Baptist Church. Rev. W.A. Tinsley was Riverside's pastor in 1922. The mill and church were on the eastern side of the city.

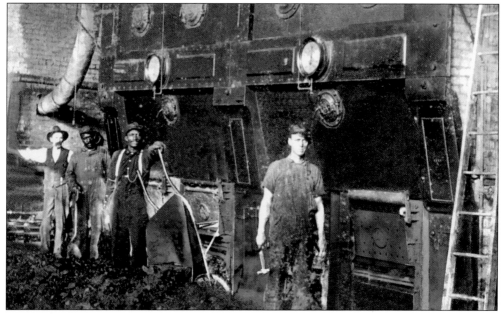

[BROGAN COTTON MILL OPERATIVES, c. 1915.] The mills in Anderson County gave housing, education, and steady employment to the unskilled rural and hill families. Fathers, mothers, and children worked in the mills. An average daily wage was 75¢ in 1902; a 3-operative family's wage was $2.05, while a 5-worker family's wage was $4.10. Full-time operatives worked 62 hours a week. Work began at 6:15 a.m., lunch was from 12 to 1 p.m. and work ended at 6:30 p.m.; Saturday's work ended at noon. Room rent was $1 per room per month; heating was $2.75 for a cord of wood or $5.50 for a coal load; board was $1.50 to $2 per week.

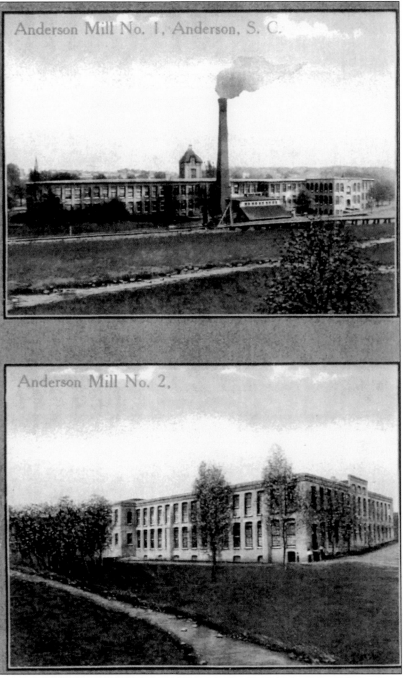

Anderson Mill No. 1, Anderson, S. C.

Anderson Mill No. 2,

ANDERSON COTTON MILL #1 AND #2, [1911.] These mills opened in 1890 and initially used steam power. Later, they converted to electrical power. The original cost was $128,500 for the main building, mill equipment, and a 25-house village. By 1906 the equipment had 70,000 spindles and 1,864 looms that consumed 10,238 bales of cotton annually and produced sheetings and print cloths valued at $894,817. The payroll was $218,342 for 900 operatives who lived in the village with a population of 2,500.

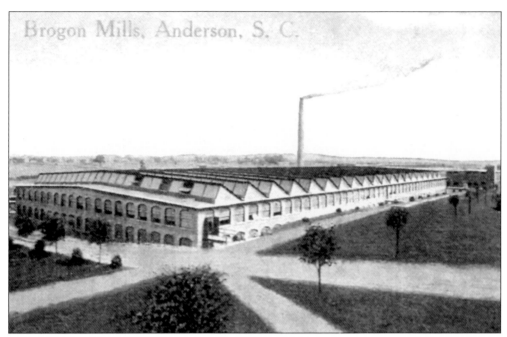

BROGAN MILLS [1911.] Brogan Mills was established in 1903 and produced flannels. In 1906 it had 26,208 spindles and 864 looms that consumed 7,000 bales of cotton annually with a cloth production valued at $1,000,000. The mill employed 600 operatives, including 4 boys under 12, and had a $198,000 payroll. The mill village had a population of 1,200 with 400 children under the age of 12.

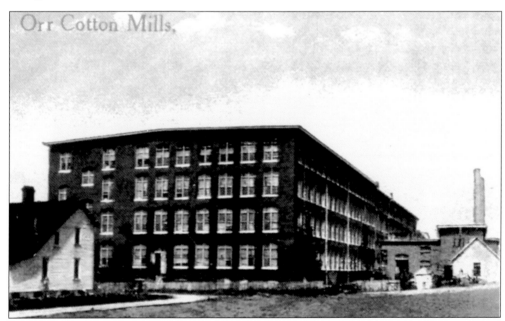

ORR MILLS. [1911.] In 1906 Orr Mill had 57,496 spindles and 1,504 looms, consumed 11,000 bales of cotton, and produced print cloths valued at $1 million. Orr Cotton Mills (1911) was incorporated in 1899 by J.L. Orr. It employed 700 operatives and had a $175,000 payroll.

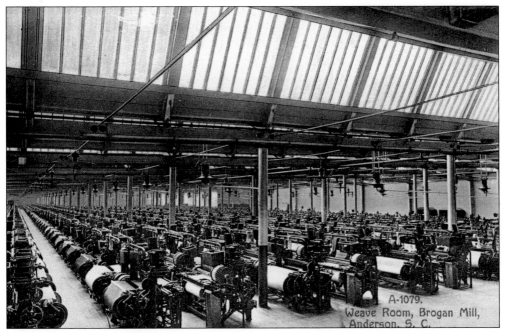

WEAVE ROOM, BROGAN MILLS [1909.] An average mill in 1906 paid operatives by mill process. Weaving earned $1.30 a day; spinning $1.06 a day; picking and carding $1.15 a day; dressing and spooling $1.02 a day; cloth room 83¢ a day; and the machine shop earned $1.39 a day. Full-time operatives worked 124 hours in 2 weeks. A 5-operative family (watchman, 2 weaving, and 2 spinning workers) earned $7 a day.

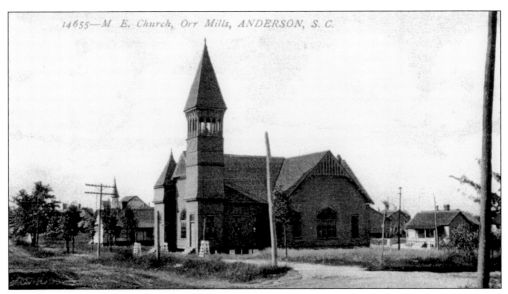

M.E. CHURCH, ORR MILLS, [1908.] The Methodist Episcopal Church on South Main Street is shown on the postcard scene above. It is one of the two Orr Mill churches that the mill built for the operatives. Directly behind the Methodist Church is the Baptist Church. The mill gave the lots, 15 percent of the construction costs, and $100 each annually for expenses. Rev. S.T. Creech was the pastor of this Methodist Church in 1905.

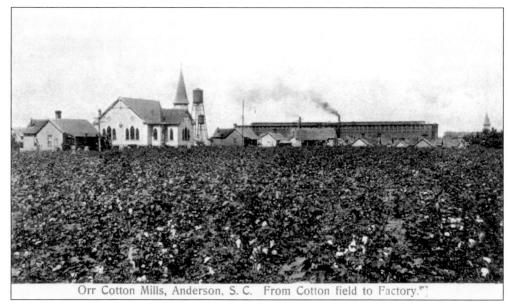

Orr Cotton Mills, Anderson, S. C. From Cotton field to Factory."

ORR COTTON MILLS, FROM COTTON FIELD TO FACTORY [1908.] This view with the cotton field symbolizes the cycle of mill economies. Farmers grew and sold the cotton; cotton was turned into fabric at the mill; and jobs were thus created for operatives. The mills supported churches and schools and contributed taxes to both local and state governments. The village Baptist Church, shown above on the left side, had a membership of 254 in 1909 and Rev. H.C. Martin was the pastor.

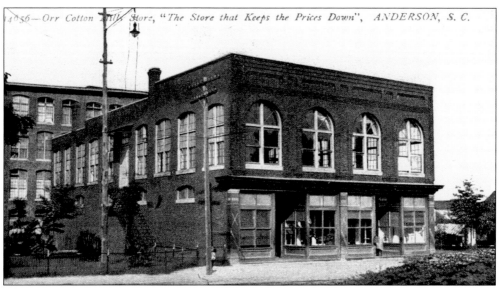

14056—Orr Cotton Mills Store, "The Store that Keeps the Prices Down", ANDERSON, S. C.

ORR COTTON MILLS STORE, [1908.] Each mill built commissary-type stores for their operatives, who were usually poor families that came to the mills seeking a steady source of income and needing low-cost housing and credit. The factory would assign the family a cottage and let them obtain food, clothing, and medicines on credit and subtract those expenses from the salaries of the fathers, mothers, and children at the end of each two-week payroll. The store stocked every necessity, including coffins.

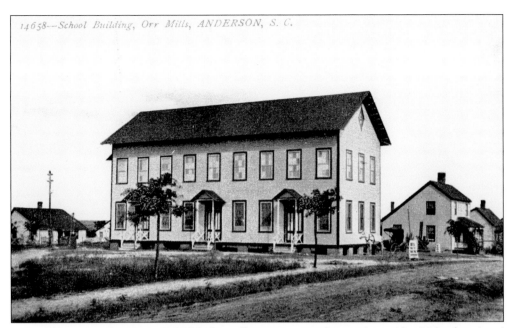

SCHOOL BUILDING, ORR MILLS, [1908.] The mill owners wanted operatives with a high educational level. August Kohn's book, *Cotton Mills of South Carolina*, called that "welfare work." This concept caused the directors to build schools with academic and industrial subjects, churches, meeting halls, and gyms. Orr Mills spent $1,000 for a 3-teacher school building for 547 students. M. O'Neal, principal, and two other teachers taught at this school in 1905.

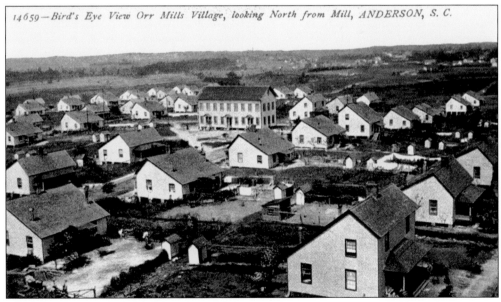

BIRD'S-EYE VIEW OF THE ORR MILL VILLAGE LOOKING NORTH FROM MILL, [1912.] This bird's-eye view of the Orr Mill Village shows the standard layout of a village with identical one-story cottages for small families and two-story structures for larger ones. In 1906 the village had a 1,500 population. The privies were located at the rear of each lot with a wagon path running between them for the entire distance of a street.

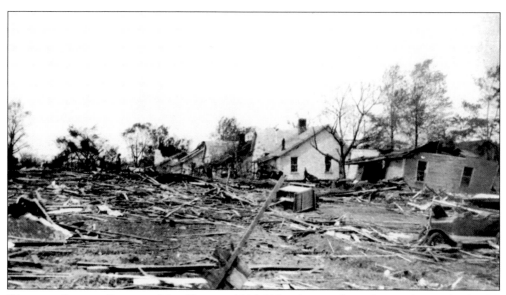

[TORNADO DAMAGE, RIVERSIDE MILL VILLAGE, 1924.] The damage from the 1924 tornado that hit Anderson's Riverside Mill and village was the worst single recorded catastrophe for the county. The postcard view above shows one scene at the mill village. Other tornadoes from this weather front struck across South Carolina for a total destruction of almost $1 million.

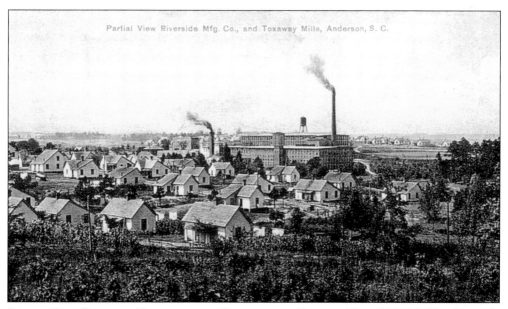

PARTIAL VIEW RIVERSIDE MANUFACTURING COMPANY AND TOXAWAY MILL, [1909.] The Riverside Mill was incorporated in 1899 and made cotton yarns up to size #30. By 1906 the mill had 18,928 spindles and processed 4,000 bales of cotton annually with a product value of $375,000. Riverside employed 225 operatives with a $50,000 payroll. Their village had a population of 600 with 200 children under 12. Toxaway Mill was incorporated in 1902. In 1906 it had 16,128 spindles, 484 looms, processed 2,400 bales of cotton, and created a product with a value of $265,000. It employed 150 operatives with a payroll of $42,000. Toxaway's village housed 500 with 110 children under 12.

Three

WESTERN ANDERSON COUNTY

Anderson County's 16 townships were Brushy Creek, Garvin, Williamston, Hopewell, Pendleton, Fork, Centerville, Broadway, Belton, Honea Path, Martin, Varennes, Rock Mills, Savannah, Hall, and Corner. In 1870 W.H. Haynie, Anderson County's school commissioner, duplicated the townships' areas in creating the school districts. In 1884, 75 percent of the workers of one mill could not read or write. Schools had the major task of reducing illiteracy. Teaching standards were raised, curricula expanded, attendance days increased, and buildings improved. In 1902, 40 school districts had 118 schools, 162 teachers, and 2564 students in the white division and 62 schools, 83 teachers, and 5440 students in the African-American division. The comprehensive 1918 public school survey of Anderson County by Lueco Gunter gave valuable insight into the structures and strengths of each school in the county. The photographs taken during his visits document the evolution of school buildings.

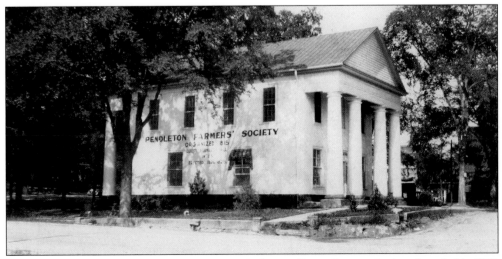

PENDLETON FARMERS SOCIETY BUILDING [C. 1910.] The Pendleton Farmers Society, founded in 1815 with Thomas Pinckney as the first president, promoted new agricultural methods. It bought the unfinished Pendleton District courthouse and completed it in 1828. The 2-story white columns were added in 1840. The building was the first permanent and oldest active Farmers Hall in the United States and became a symbol for Anderson County's progressive agriculture.

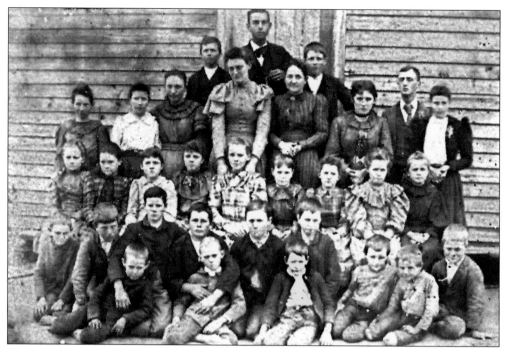

[STUDENTS, SLABTOWN ACADEMY, 1896.] The Slabtown Academy evolved from the early Thalian Academy of 1832 near Slabtown. It was marked by the Slabtown A.R.P. Church on the 1897 county map. In 1900 the Slabtown Academy was located in Brushy Creek School District #4, which had two white 1-teacher schools with 108 students and one black 1-teacher school for 65 students. The site was located near the Pickens County line on S.C. 88 near A.C. 567.

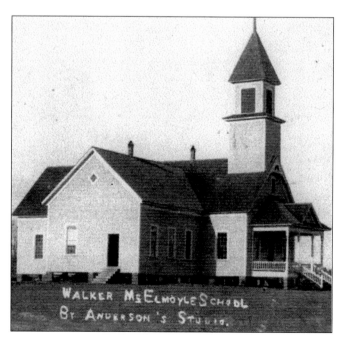

[WALKER-MCELMOYLE SCHOOL, c. 1915.] The Walker-McElmoyle School had its beginnings in 1882 when Mrs. E.J. Walker deeded land for a college. In 1900 the school was in Garvin School District #3, which had two white 2-teacher schools and four 1-teacher schools with 312 students. The Walker-McElmoyle School, at U.S. 178 and S.C. 88, became District #50 and its school library was established in 1905. The 1918 school survey indicated a 4-teacher school with 154 students in grades 1 through 10 with a 140-day school term.

66

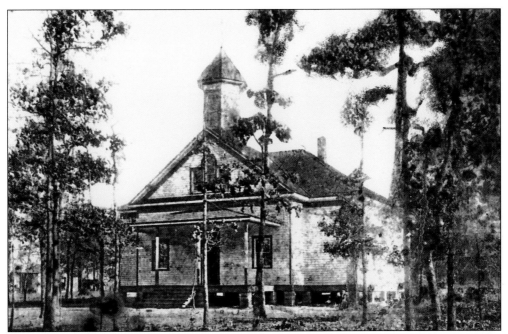

[HOPEWELL SCHOOL, c. 1915.] The Hopewell Township was named after the Hopewell Baptist Church and was marked on the 1877 county map. The 1897 county map also marked this school. The 1900 Hopewell School District #7 had six white 1-teacher schools with 238 students. Gunter's 1918 Anderson County school survey indicated that the 2-teacher Hopewell school had 61 students in a 160-day term. It was located near Hopewell Church by S.C. 81 and A.C. 29.

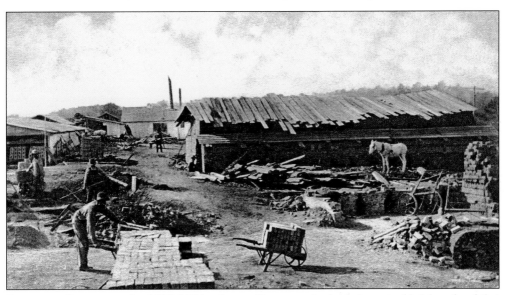

BRICKYARD, PENDLETON, [c. 1908.] This picture illustrates the basic layout of brickyards of that era. Local laborers often learned the basic skills of selecting proper clay bodies and building simple kilns to make bricks for public and commercial buildings. Planters and merchants who established summer homes away from the coastal regions often preferred brick structures, which created a demand for bricks. These clays were also used in making domestic pottery.

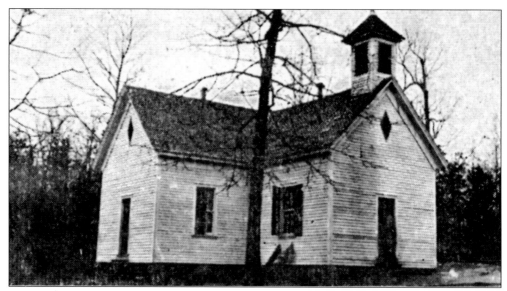

[ST. PAULS SCHOOL, 1918.] St. Paul School, the second school in the Brushy Creek School District #4 in 1900, had two white 1-teacher schools with 108 students and a single black 1-teacher school for 65 students. The St. Paul School, St. Paul Methodist Church, and the road by the site all bear the same name and are located near the Pickens County line. In 1918 the school was described as having an inadequate 1-teacher building with 56 students.

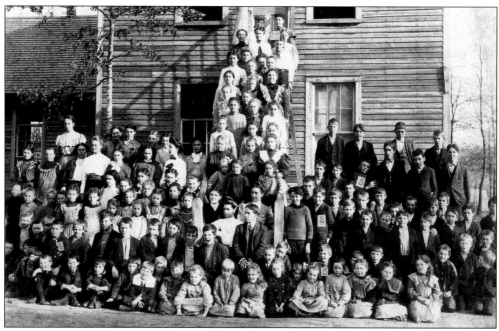

[STUDENTS, LEBANON SCHOOL, 1900.] The 1900 Lebanon School District #27 had one white 3-teacher school in a 2-story frame structure with 141 students. This Lebanon School and Baptist Church was marked on the 1897 county map near Sandy Springs Road, A.C. 705, and Liberty Highway, U.S. 178. The school's library was begun in 1905. The 1918 report called the building old and inadequate. The 149 students were in grades 1 through 10 and in a 160-day term.

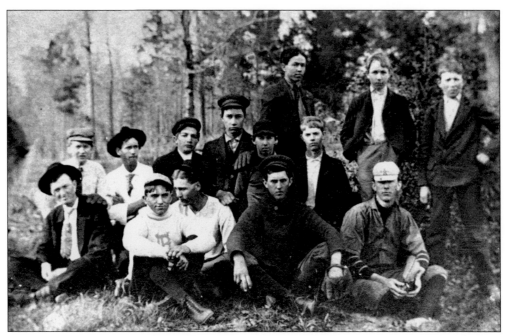

[LEBANON BASEBALL TEAM, 1908.] The Lebanon Baseball Team consisted of a group of young men from the Lebanon community. They enjoyed the competition of playing teams from the numerous communities of the area or towns near the railroad lines. Cotton mills and towns like Anderson and Greenville had teams as early as 1900.

[DENVER SCHOOL, c. 1918.] In 1900, the 1-room Denver School (near the depot on the Blue Ridge Railroad) was in Pendleton School District #2, which had six white schools and 8 teachers with 255 students. By 1918 the Denver School had expanded into a modern 3-teacher, single-story 3-classroom school with 119 students in grades 1 through 7 in a 140-day term. The Denver site was west of U.S. 76 and north of U.S. I-85 near Sandy Springs.

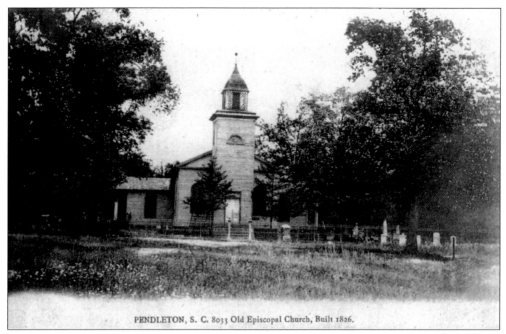

PENDLETON, S. C. 8033 Old Episcopal Church, Built 1826.

OLD EPISCOPAL CHURCH, PENDLETON [c. 1910.] St. Paul's Episcopal Church, Pendleton was completed in 1822. The construction materials for the church were shipped from Augusta, Georgia. The original bell was melted down during the Civil War for ammunition casings. The furnishings are original and the G. Jardine Company hand-pump organ was purchased in the 1840s by Mrs. John C. Calhoun and others.

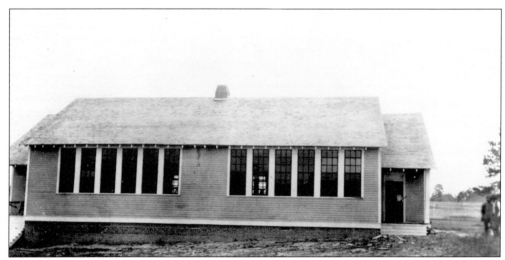

[MOUNTAIN SPRINGS ROSENWALD SCHOOL, 1926.] Mountain Springs Baptist African-American Church was marked on the 1877 and the 1897 Anderson County maps. In 1900 Garvin Township School District #3 had two 1-room schools for 98 black children. This church in District #3 constructed a school on their site. That inadequate structure was replaced by a 4-teacher Rosenwald Fund school during the 1924–1925 school term. The school cost $5,100 in which the black parents and church members paid $2,000, the Anderson School system $2,000, and the Rosenwald fund $1,100.

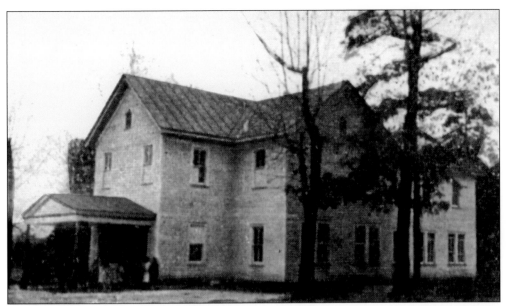

[THREE & TWENTY SCHOOL, 1918.] Three and Twenty School site was marked on the 1897 county map. In 1900 it was District #32 and had two white 1-teacher schools with 47 students. Later, this school was a 2-story building with an upstairs auditorium. In 1918 it was a 4-teacher school with 146 students in grades 1 through 10 in a 140-day term. It was located on A.C. 485, now called Three and Twenty Road and Ridge Road.

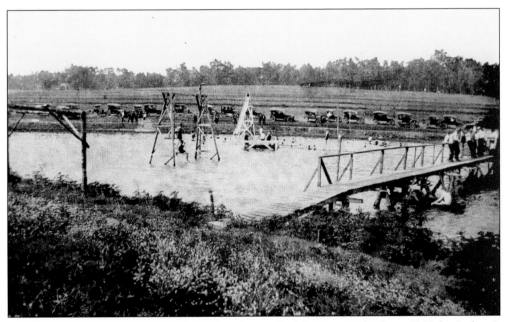

BOSCOBEL LAKE, NEAR PENDLETON. The initial Boscobel house was built in 1835 by Judge S. Prioleau of Charleston. It was later purchased by Dr. J.B. Adger, a Presbyterian missionary, who named it after Boscobel House and Parish in England. Later, Mr. H.C. Summers obtained the property. In the 1920s his sons, Clint and Jack, developed a Boscobel golf course and Boscobel Lake for swimming.

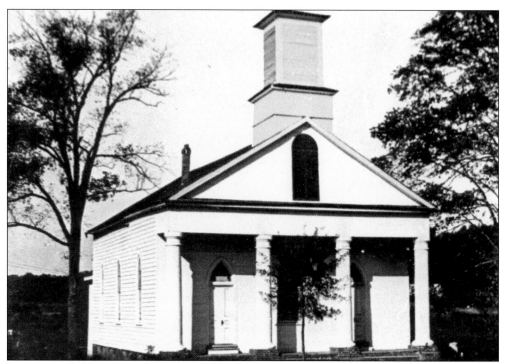

[Baptist Church, Pendleton, c. 1910.] The Baptist Church of Pendleton was organized in 1842 and its first sanctuary was constructed in 1843. Rev. Thomas Dawson was its first pastor. Rev. J.R. Moore was the pastor in 1909 when the church had 89 members. Plans for a new church were begun in 1948 and the new sanctuary was dedicated in 1951.

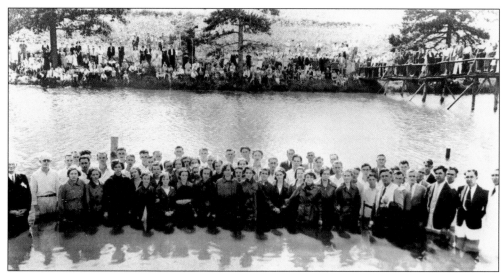

[Baptism, La France Baptist Church, Burns Lake, 1934.] The La France Baptist Church was organized in 1893 as a church for the Autun Mill village. In 1906 the mill had 58 workers who lived in its mill village. The mill school enrolled 26 of the 125 children living there. The La France Baptist Church congregation is shown watching the baptism of a large number of its members at Burns Lake in 1934 when Dr. E.C. White was the pastor.

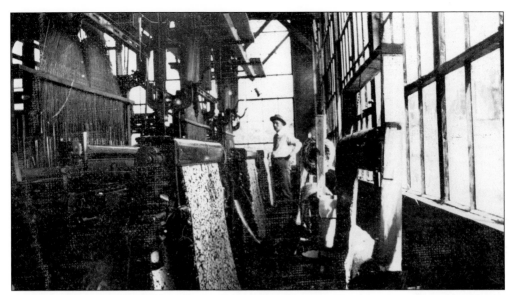

[AUTUN COTTON MILL, c. 1925.] The Pendleton Manufacturing Company was erected beside the Three and Twenty Creek in 1838 and had 960 spindles. Fifty young girls were the operatives who made the yarns. It was sold in 1866 and again in 1879 when its name was changed to Autun. In 1906 it had 2,500 spindles and consumed 1,800 bales of cotton. The value of its product was $147,000. The payroll for the 58 operatives was $113,500. It became the La France Mill when it changed owners in 1927.

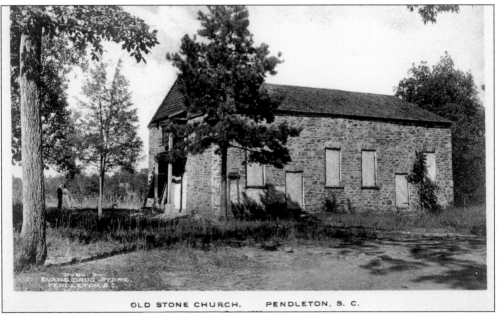

OLD STONE CHURCH. PENDLETON, S. C.

OLD STONE CHURCH, [c. 1908.] Old Stone Presbyterian Church, Pendleton (now in Pickens County) evolved from the Hopewell Church, a log structure built in 1785 by Pendleton's Scots-Irish and was used until 1799. A new site was chosen in 1797 and a church made of rough native stone was built and dedicated in 1802. Revolutionary generals Andrew Pickens and Robert Anderson worshiped there. Its first pastor was Mr. Simpson.

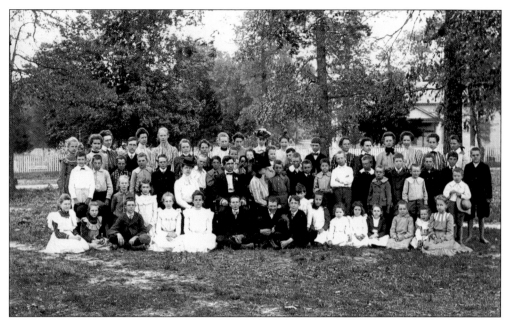

[PENDLETON SCHOOL CHILDREN, 1902.] The earliest Pendleton school was incorporated in 1811. Various academies continued through the 19th century. In 1900 both the Pendleton School and Autun School were in the Hunter School District #24, which had two white schools with 4 teachers and 129 students and two black schools with 3 teachers and 176 students. Pendleton school children of 1902 are shown above. Pendleton School's library was established in 1905.

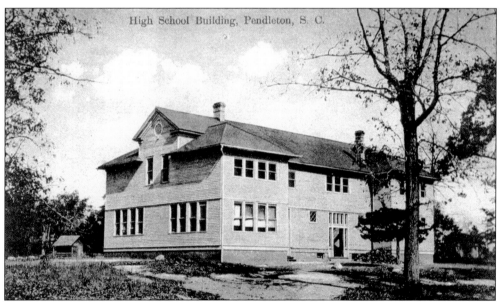

HIGH SCHOOL BUILDING, PENDLETON, [C. 1912.] Hunter School District #24's Pendleton high school building was a 2-story frame structure with 7 classrooms and an auditorium. Gunter's 1918 review stated that the school's 231 students were divided into 7 elementary grades taught by 5 teachers while 2 teachers taught the 37 high school students. The population was 800 in 1910.

METHODIST CHURCH, PENDLETON. Pendleton's Methodist Church was organized in 1834 and was one of 19 churches in the Pendleton Circuit with 792 members. They bought a lot in 1840 and built a frame edifice there. Ten churches were in the circuit in 1872. The Pendleton Methodist Church had a membership of 94 in 1883. In 1901 R.E. Stackhouse was the circuit pastor. The frame sanctuary was struck by lightning in May 1938 and destroyed. A new building was erected in November 1938. The Pendleton Methodist Church withdrew from the circuit in 1950 and became a station church with a full-time pastor.

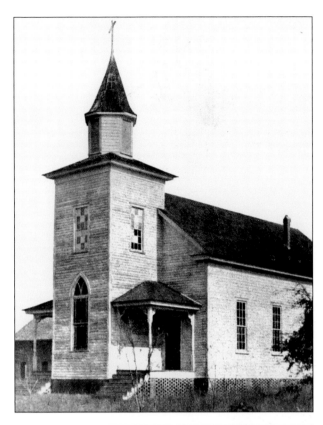

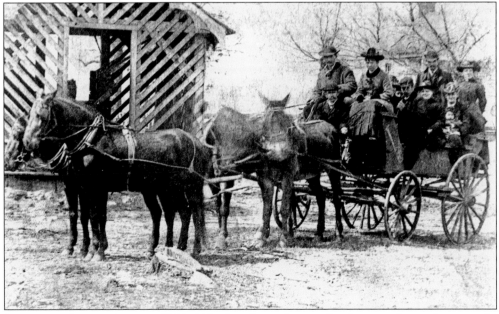

[**PENDLETON CONCERT BAND**, *c.* **1920s.**] The Pendleton Concert Band was made up of community members who would play at local events and holidays. Most South Carolina localities had bands to entertain at public functions.

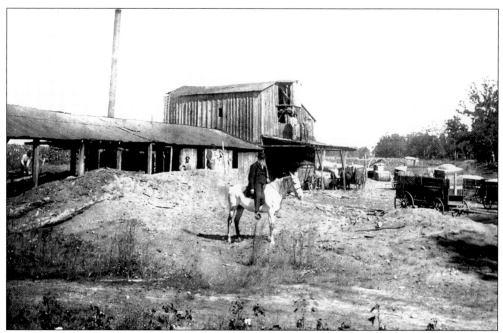

[DR. W.K. SHARPE, TOWNVILLE, *c.* 1910.] Dr. Sharpe of Townville is seen on his horse at Rivioli Plantation near Pendleton. Like many doctors of that era he would ride across his rural region to tend to the sick in their homes and carry his medicines in his saddlebags. He died in 1920.

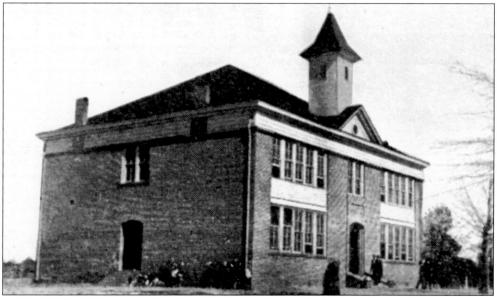

[TOWNVILLE SCHOOL, 1918.] In 1902 Townville School District #40 had a white 1-teacher school with 54 students and a black 1-teacher school with 21 students. Its school library was established in 1905. By 1918 the school district had built a modern 2-story brick high school with 6 modern classrooms and an upstairs auditorium. The 222 students, including 62 Oconee County children, had 4 elementary teachers. The high school section had 2 teachers and 37 students. The site was on S.C. 24. Townville population was 450 in 1910.

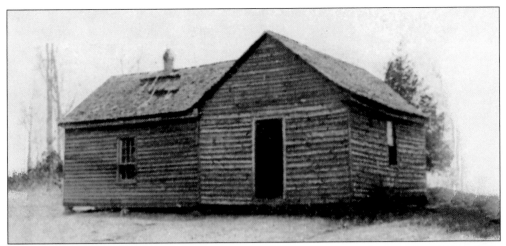

[NEW LIGHT SCHOOL, 1918.] The New Light Baptist Church was marked on the 1877 and the 1897 county maps. The school was initially supported by its mother church, which was in the Pendleton School District #2 in 1900. The 1937 Anderson County highway map placed the school across S.C. 187 from the church and above A.C. 162. It was in Zion School District #53 by 1905. The building was erected by the members of the New Light Church during the first decade. These schools were not owned by the county. Gunter's 1918 school survey visited and photographed this school.

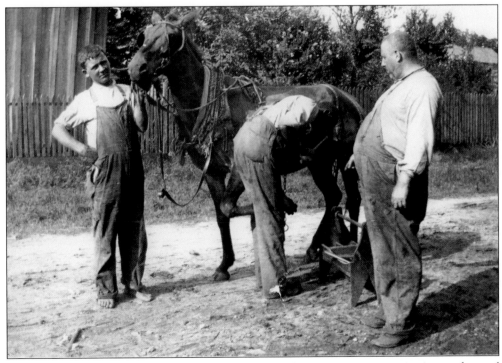

[JOHN PALMER, BLACKSMITH, PENDELTON, C. 1910.] In the 1900s every community used actual horse power. The horse was the main mount; the mule was used for hauling, while the ox was used for heavy pulling on muddy sites. John Palmer, Pendleton's blacksmith, was one of the local craftsmen who could make, adjust, or replace the horseshoes.

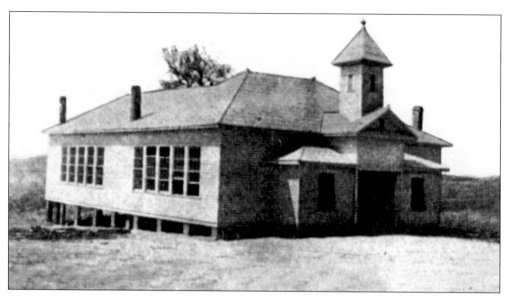

[FORK SCHOOL, 1918.] The Fork School shown above was constructed *c.* 1910 and followed state design and guidelines. The initial 1900 Fork School District #1 had two white 2-room schools and four 1-room schools with eight teachers and 365 students while the black division had a 1-teacher school for 46 students. In 1918 Gunter's report described this District #40 3-teacher school as a modern one with 54 students in grades 1 through 8. The Fork School site was located north of U.S. I-85 on Fork School Road and Dobbins Road (2002).

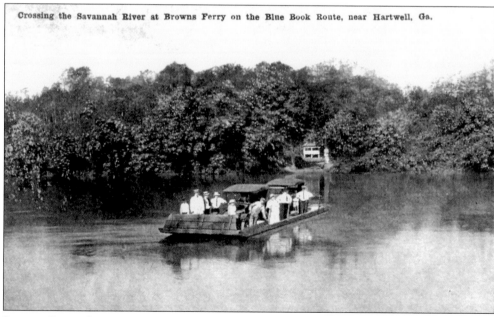

Crossing the Savannah River at Browns Ferry on the Blue Book Route, near Hartwell, Ga.

BROWNS FERRY, SAVANNAH RIVER, [1920S.] Browns Ferry, initially called Shockley Ferry, was a major crossing of the Savannah River in Anderson County. It gained a notorious reputation due to the murder of young Union soldiers guarding bales of cotton during the Reconstruction period. The road to this ferry passed both the Shiloh Baptist Church and Ruhamah Methodist Church before crossing the river to Hartwell, Georgia.

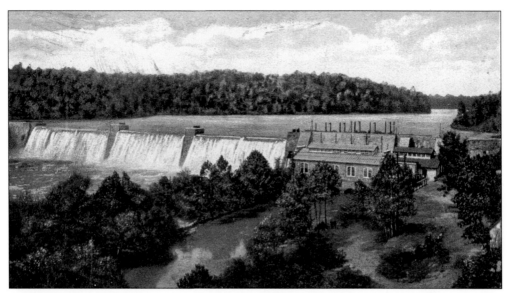

PORTMAN SHOALS POWER PLANT, SENECA RIVER, [c. 1920s.] W.C. Whitner conceived the idea of the long distance transmission of electric power in 1894. First a small plant was established at High Shoals on the Rocky River six miles from Anderson. It transmitted 200 electrical horsepower from 5,000-volt generators. Then the Portman Shoals Power Plant on the Seneca River, a 10-mile distance, was built by the Anderson Light & Power Company. Construction began in 1896. It used Stanley Electric Company's 11,000-volt generators. The Portman dam, swept away in December of 1901, was rebuilt and returned to service in September 1902. The plant caused Anderson to be called the "Electric City."

[ZION SCHOOL, 1918.] Zion School was a 1-room school in Pendleton School District #2 in 1900, which had 6 white schools and 8 teachers with 255 students. It was initially supported by the Zion Methodist Church, which was marked on the 1897 map. Zion's school library was established in 1905. The 1918 school review listed Zion School in District #53 as a 4teacher modern building with 4 classrooms, and 160 students in grades 1 through 11. It was located north of U.S. I-85 and S.C. 187 and by Zion Methodist Church.

[GREEN POND SCHOOL, 1918.] Green Pond School was located on S.C. 24 and A.C. 34 southwest of New Prospect Church. In 1900 this site was in Centerville School District #6, which had four white 1-teacher schools with 241 students while the black division had two 1-teacher schools with 250 students. After 1910 the Centerville District was divided, with the western half becoming Green Pond District #69. In 1918 Green Pond was a modern 3-teacher school with 97 students in grades 1 through 7 in a 138-day session.

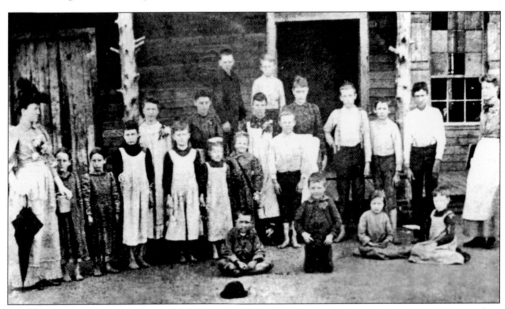

[STUDENTS, WILLIFORD STORE SCHOOL, 1893.] The Williford Store School (1893) was located in Rock Mills Township and was marked on the 1897 map. In 1900 Rock Mills School District #5 had five white 1-teacher schools with 190 students. Miss Nannie Poole was the teacher in 1893. Later, the Williford School District #62 was created. The site in 2002 is located near S.C. 187 south of Providence Church and near Williford Road.

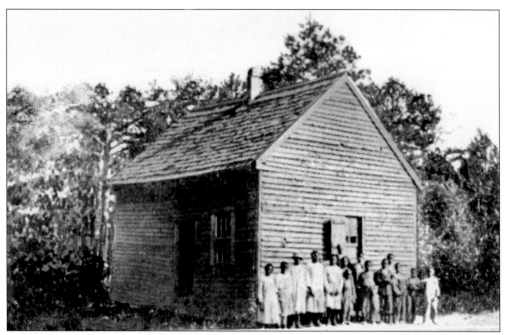

[MT. PLEASANT SCHOOL, 1918.] In 1900 this Mt. Pleasant School site was in the Fork School District #1, which had a 1-teacher black school with 46 students. Many of the initial African-American schools met in their churches with the minister as the teacher. The members of the church built a simple frame structure for their school. The Mt. Pleasant School was in Broyles School District #57 in 1918. It was located south of Interstate U.S. I-85 and A.C. 237, across the road from the Mt. Pleasant Church.

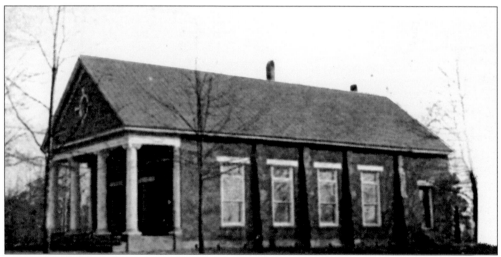

[MOUNTAIN CREEK CHURCH, 1918.] The Mountain Creek Baptist Church was organized in 1789. After the Civil War the black members established their own church, which housed their school as late as 1918. The Varennes School District #10 had four black 1-room schools with 285 students in 1900. It was located by U.S. 29. The 1918 Anderson County survey found 17 men and 80 women teachers in 57 black 1-teacher schools, 4 schools with 2 teachers, and 4 schools with 3 or more teachers. Their average salary was $135.

81

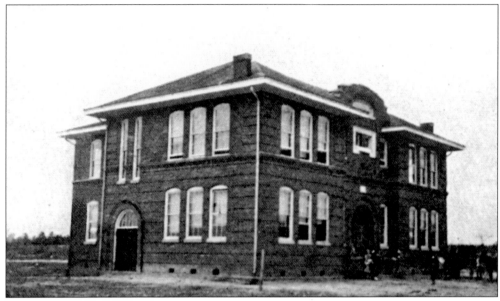

[STARR SCHOOL, 1918.] In 1902 the Starr School District #37 had a white 1-teacher school with 53 students and a black 1-teacher school with 63 students. The school library was started in 1905. By 1918 the school had grown to a 5-teacher modern brick edifice with 4 classrooms downstairs and 2 classrooms and an auditorium upstairs. The 174 students were in grades 1 through 10 in a 160-day year.

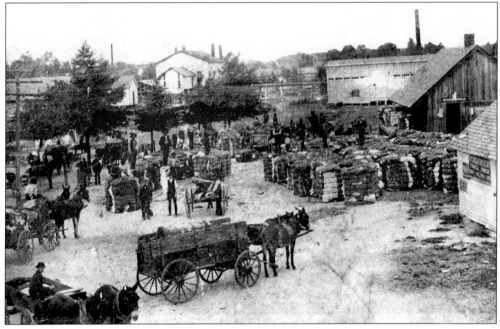

[COTTON GIN, STARR, C. 1890s.] The Starr Depot was established on the Savannah Valley Railroad in 1886, which later became the Charleston and Western Carolina Railroad line. The site evolved into the nucleus of a rural community center. Local farmers brought their cotton harvest to be ginned. In 1910 the population was 300.

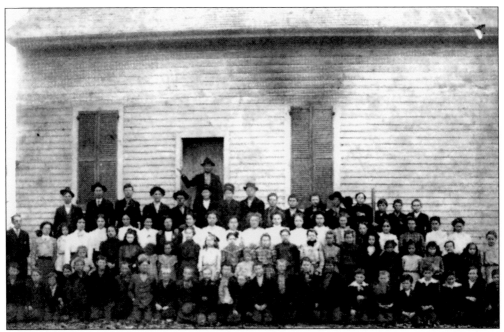

[DOUBLE SPRINGS CHURCH MEMBERS, c. 1909.] Double Springs Baptist Church was marked on both the 1877 and the 1897 Anderson County maps. Rev. R.A. Smith was the pastor of the Double Springs Baptist Church in 1909, which had a membership of 149. It is located south of U.S. I-85 in 2002.

[DOUBLE SPRINGS SCHOOL, 1918.] In 1900 this Double Springs School was in Fork School District #1 as one of six 1-teacher schools. In 1909 Double Springs School District #68 established its school library. In 1918 Gunter visited this modern single-story 3-teacher building, which had 119 students in a 140-day term. This school was located south of U.S. I-85 on Double Springs Road (2002).

[MCLEES SCHOOL STUDENTS, c. 1920s.] McLees Academy (1897 map) was located south of New Hope Church on S.C. 104. This site was in Rock Mills School District #5 in 1900 and was one of five 1-teacher schools. By 1905 McLees School was in its own School District #52 and had a library. It was an old 2-story structure in 1918 when it was a 3-teacher school with 94 students in grades 1 through 10. The picture above shows McLees's students in the 1920s.

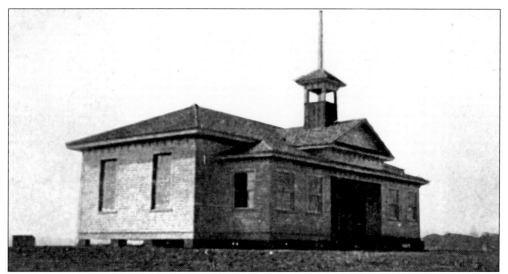

[SHILOH SCHOOL, 1918.] Shiloh School was shown on the 1897 county map as being on the grounds of the Shiloh Baptist Church. In 1900 it was in the Savannah School District #9, which had four white 1-teacher schools with 195 students. By 1905 the Shiloh School became District #49 and had a school library. In 1918 this school was a 2-teacher school with 50 students in grades 1 through 10 in a 136-day term and located on U.S. 29 near the Savannah River. Its site is now under Lake Hartwell.

[GENEROSTEE A.R.P. CHURCH, *c.* 1910.]
The Generostee Associate Reformed
Presbyterian Church *c.* 1790 is the oldest
A.R.P. Church in the county and was
marked on the 1897 county map. Its name
came from the Little Generostee Creek,
which was a derivative of the Indian's
"Atchinaausdi," which meant "little cedar."
The initial site, west of Iva, was between
Campbell and Parker Bowie Road (2002).
The church was destroyed by fire in 1985.

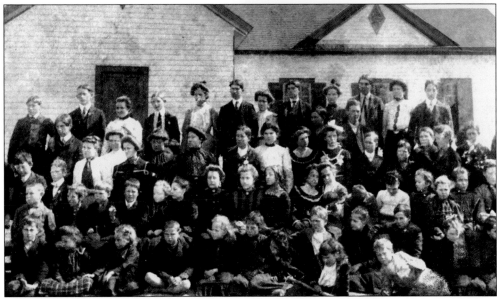

[GOOD HOPE SCHOOL, *c.* 1920s.] Good Hope School, near Iva, was located by S.C. 81 and A.C.
154. The school's roots evolved from the Good Hope Presbyterian Church's congregation, which
began in the 1790s. The initial Good Hope school was built in 1901 and was in Hall School
District #14 in 1901, which had five white 1-teacher schools with 197 students. It became School
District #43 by 1904. It was a 2-teacher school in 1918 with 58 students in grades 1 through 8.
The school student picture above was taken in the 1920s.

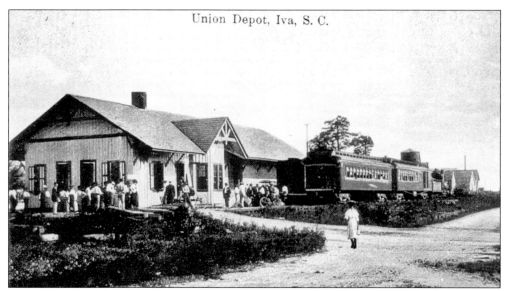

Union Depot, Iva, S. C.

UNION DEPOT, IVA, [1910.] The first depot was built on the Savannah Valley Railroad in 1885 and was initially called Cook's Station after Dr. A.G. Cook. However, Cook preferred it to be named after his daughter Iva. The railroad was called the Charleston and Western Railroad in 1910. This railroad began as a route that would connect Augusta to Anderson with depots at Barnes, Iva, Starr, and Dean. Iva's population was 650 in 1910.

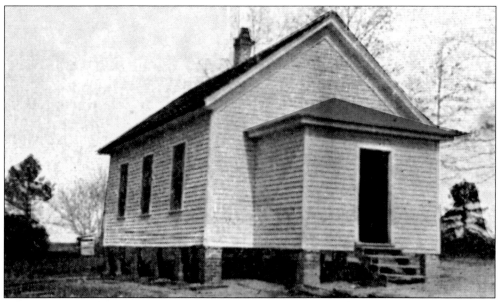

[GENEROSTEE SCHOOL, 1918.] The initial Generostee School was built on the grounds of the Generostee A.R.P. Church, as shown on the 1897 county map. It was in the Corner School District #13 in 1900, which had a white 2-teacher school and five 1-teacher schools with 254 children. This school above was the third frame school built on the same site some 3 miles west of Iva on Parker Bowie Road (2002). The 1918 survey reported that it was a comfortable building for the elementary students. Higher grades went to Iva. Later the Generostee School became District #61.

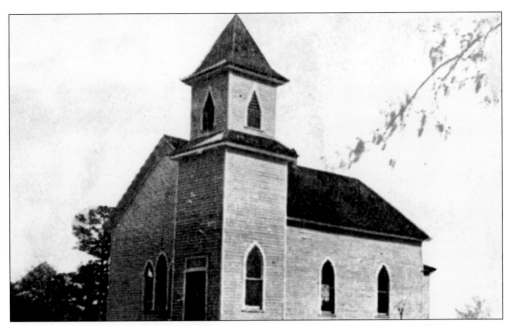

[MOUNTAIN VIEW METHODIST CHURCH, 1918.] Mountain View Methodist Episcopal African-American congregation began as a "brush arbor" church and later built a sanctuary near the Savannah River. The 1900 Corner School District #13 had four black 1-teacher schools with 198 children. The church served as a school house up to 1918. Both the church and school were located on S.C. 187 near McGee Ferry Road, which later became Generestee School District #61.

[CHOIR, IVA, c. 1920s.] The Belton Singing Convention of 1869 invited all choir members to participate in their program. The participants brought their musical experiences back to their local churches. The Choir of Iva was a typical singing group of this era before radio, television and movies. Families created their own entertainment by learning how to play musical instruments and organize choirs for church and public events.

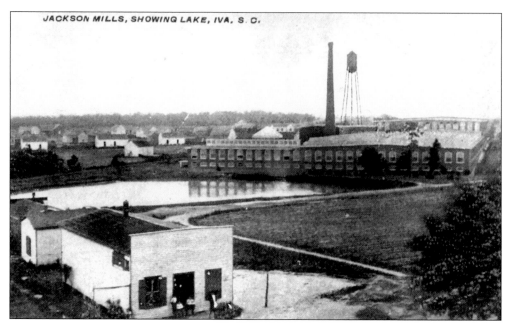

JACKSON MILLS SHOWING LAKE, IVA, [1910.] Jackson Mills was organized in 1904 by Alfred Moore (president) and Thomas C. Jackson (manager and treasurer) with a capital of $325,000. In 1906 the mill had 20,160 spindles and 640 looms; processed 7,000 bales of cotton annually; and made sheetings with a product value of $486,000. The postcard view above shows the mill store in the foreground, with the pond, mill, and village in the background.

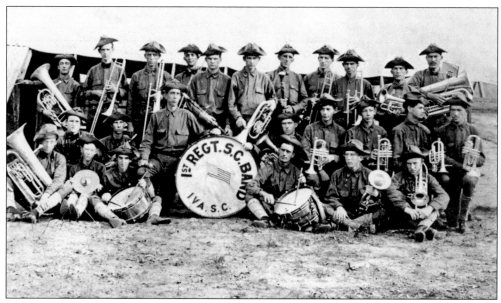

FIRST REGIMENT SOUTH CAROLINA BAND, IVA, [c. 1915.] Jackson Mills sponsored units of First South Carolina Regiment of the National Guard, which saw service in 1916 in Texas. Later, it became the 118th Infantry, Company C that was merged into 30th Division in World War I. Their band entertained audiences in parades, events, and ball games and participated in local and state events.

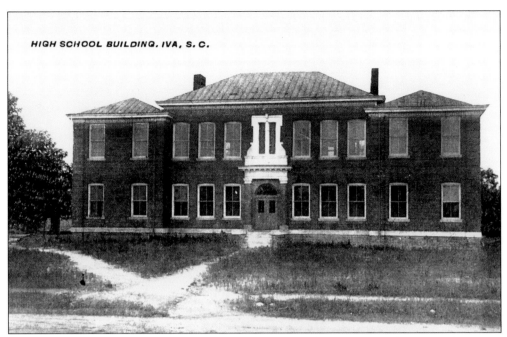

HIGH SCHOOL BUILDING, IVA, S. C.

HIGH SCHOOL BUILDING, IVA [*c.* 1910.] This high school building was erected in 1908. The 2-story brick structure had five classrooms and an auditorium that cost the mill $1,500. The 1918 survey recorded 8 teachers and 326 students in grades 1 through 10. Five teachers taught elementary classes and two teachers and the principal taught 42 students in high school classes.

[RUHAMAH METHODIST CHURCH, *c.* 1930s.] Ruhamah Methodist Church was organized in 1822 and was dedicated in 1836. Its name came from Hosea in the Bible. Camp Meetings were held at this site from 1830 to 1848 and the sanctuary was marked on the 1897 county map. It was on a rural charge with the Hebron and Starr Methodist Churches. This site was located in the Savannah township on U.S. 29 and near the Shiloh Baptist Church and school. Since it was near the Savannah River, the site is now under Hartwell Reservoir.

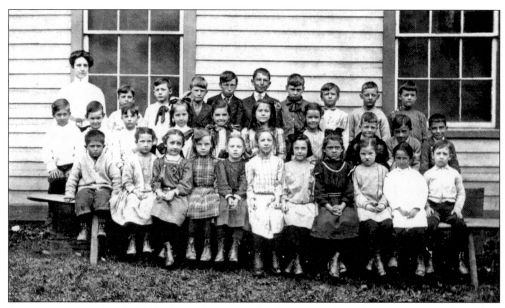

SCHOOL CHILDREN, IVA, [*c.* 1907.] Iva Elementary Students pose for a class picture outside of their initial frame schoolhouse. These students with limited education were taught basic grammar and math so that they could move into the mill labor force at an early age and become the mill's major workers. It was important that they could read and interpret the instructions on operating the mill machinery safely.

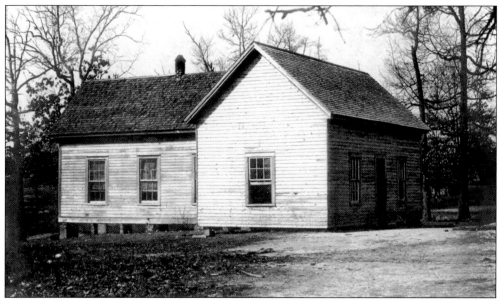

[IVA SCHOOL, *c.* 1907.] Iva School was initially in the 1900 Corner School District #13. The white division included one 2-teacher and five 1-teacher schools with 254 students. This L-shaped 2-room frame school was built *c.* 1904. It served the young children of the Jackson Mill Village. J.W. Ligon was the principal. In 1905 the Iva School District #44 was created out of the Corner District, and the school library was established. Iva's building stood between the Methodist Church and the new school site. It was torn down when the brick schoolhouse was erected.

[THE ASSOCIATE REFORMED PRESBYTERIAN CHURCH, IVA *c.* 1910.] This A.R.P. Church was located at Green and Betsy Streets in Iva. It was organized on November 8, 1895 by the second Presbytery with 21 charter members. The first church building was built *c.* 1897. The frame building to the right was erected in 1907 on a site near the present manse.

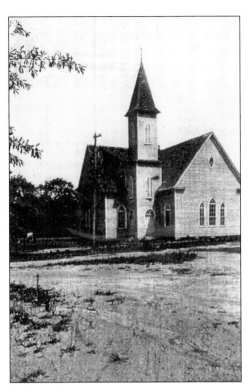

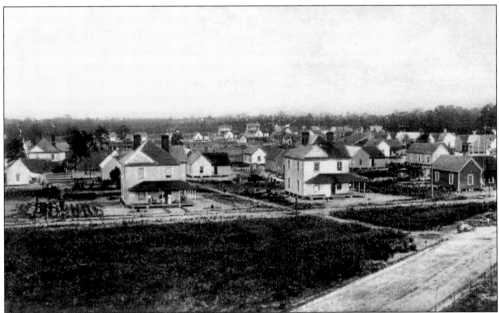

PARTIAL VIEW, JACKSON MILL VILLAGE, IVA [*c.* 1910.] Jackson Mill initially employed 225 operatives with a $73,000 payroll. This distant postcard view of the Jackson Mill Village shows some of the 150 cottages that housed its 1,500 inhabitants. The 3- and 4- room frame houses rented for 25¢ a room per week. Water and sewage were furnished. Spaces by each house permitted gardens for the families, which reduced their weekly expenses.

[TAVERN, VARENNES, c. 1930s.] The tavern was located on what was once called the Old General's Road, currently called U.S. 28 near Varennes Church Road (2002). It was built c. 1800 and was a popular trading post on the stagecoach road leading to Anderson and Pendleton. It was named after the old Varennes Church and was placed on the Historic American Buildings Survey in 1940. During the 20th century it was used as a residence and then for storage before being gutted by fire in 1982.

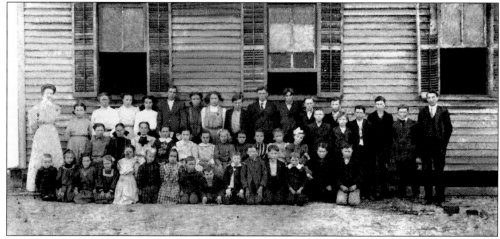

[SNOW HILL SCHOOL, c. 1920s.] Snow Hill School was in Martin School District #15 in 1900, which had eight white 1-teacher schools with 365 students. In 1909 a school library was established at Snow Hill. The initial old 1-room structure was replaced by a 2-teacher building. In 1918 it was described as an inadequate building for the 87 students in a 120-day term. It was located near Abbeville County line at the junction of Old Trail Road (2002) and Asaville Church Road.

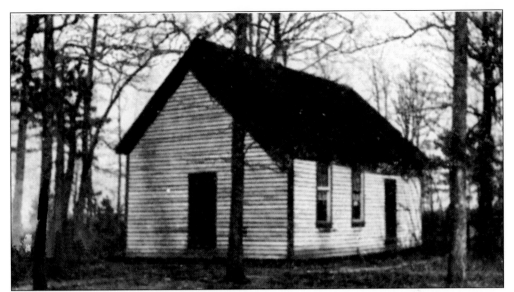

[VARENNES SCHOOL, 1918.] The Old Varennes Academy was active in 1814 and was created by Rev. T. Baird, pastor of the Varennes Presbyterian Church. Varennes School District #10 in 1900 had six white 1-teacher schools with 298 students. The 1918 evaluation considered the 1-teacher Varennes School inadequate and suggested that Varennes, Carswell, and Hebron schools, with 129 students, consolidate. The new school was called Bowen School and was at the junction of A.C. 49 and A.C. 476. Varennes School was near S.C. 28 and Varennes Church Road (2002).

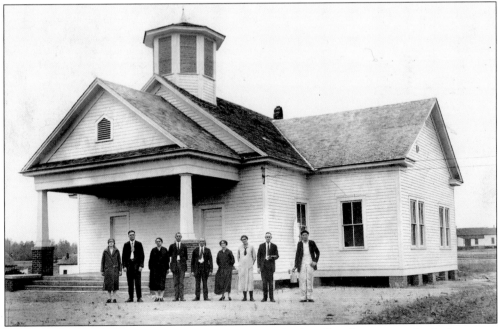

[WESLEYAN CHURCH, IVA, c. 1918.] The Wesleyan Methodist Church was organized after a tent revival that was directed by Rev. J.M. Hames in the spring of 1917. He became the first pastor of the church located on Poplar Street in Iva. The frame building above was erected soon after the organization. Later, the front porch was enclosed and the exterior was encased in bricks.

[SAVANNAH SCHOOL, 1918.] Located near the Abbeville County line, Savannah School was a replacement for a previous 1900 school in the Corner School District #13, which had five white 1-teacher schools and a 2-teacher school with 254 white students. In 1918 Gunter described this 1-teacher school as an inadequate building. Savannah, Hebron, and Varennes were consolidated into Bowen School in 1924.

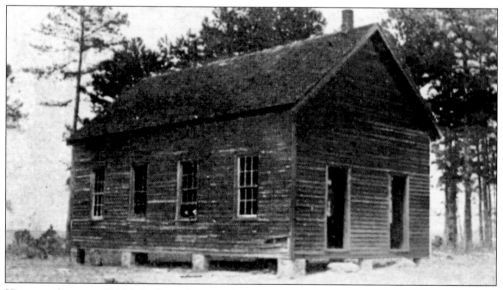

[BETHANY SCHOOL, 1918.] Bethany Baptist Church and school was marked on the 1897 map in Martin Township School District #15, which had eight white 1-teacher schools with 365 students in 1900. By 1905 Bethany School became District #46. Gunter's 1918 survey said a modern 2-teacher school for the 69 students should replace the old building. Bethany's site and that of its mother church across the road was at the junction of Old Trail Road (2002) and Bethany Church Road.

Four

EASTERN ANDERSON COUNTY

Anderson County had 731 square miles and the land was productive with corn, cotton, grain, and tobacco. Crops of 800 to 1,200 pounds of seed cotton and 14 to 40 bushels of corn were grown per acre on uplands with 30 to 70 bushels of corn on bottomlands. The wheat crops ranged from 8 to 40 bushels while oats varied from 25 to 100 bushels per acre. The eastern side of Anderson County, its border defined by the Saluda River, became sites for cotton mills that were the economic backbone for this area. The several shoals were ideal for hydro-electric plants. In 1906 Anderson County produced 50,791 bales of cotton, and the 16 county mills processed 113,672 bales. Anderson County's 16 cotton mills in 1912 had a total of 615,000 spindles, employed 10,000 operatives, and processed 150,000 bales of cotton.

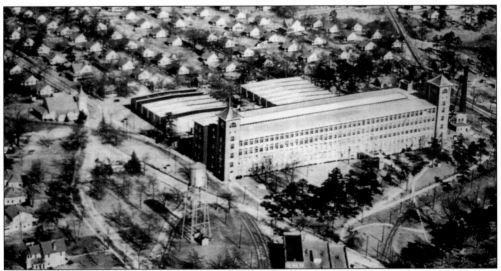

AERIAL VIEW, UPPER VILLAGE, PELZER MILL, [C. 1930s.] The aerial view above of Pelzer Mill #4 illustrates the proximity of the village to the factory. Operatives paid 50¢ a room per month for a 2-room cottage measuring 16 by 16 feet with a back-room kitchen of 12-by-16 feet, which had a sink and running water. There was a back piazza with a closet for vegetables and storage and a front piazza for evening relaxation. These houses were heated by coal grates, with coal costing $5 per ton.

[FLAT ROCK PRESBYTERIAN CHURCH, c. 1907.] The Flat Rock Presbyterian Church began meeting with the Baptists in a grove of trees in the early 1850s. A union church building was constructed in 1855 and used by both denominations at separate times. The church was marked on the 1897 county map. In 1906 the building above was erected for the Presbyterians. The site is by Flat Rock Road and near S.C. 81.

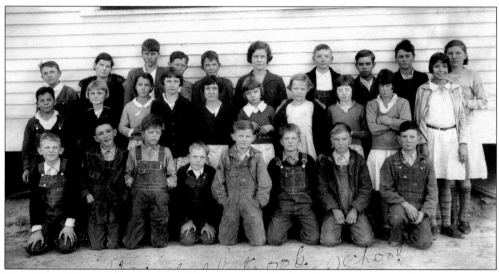

[FLAT ROCK SCHOOL CHILDREN, c. 1930s.] Flat Rock School was shown on the 1897 map by Flat Rock Church. The Flat Rock School District #38, created in 1902, had three white 1-teacher schools with 80 students. The 1918 school survey listed this old 1-teacher building as totally inadequate. A new 3-teacher modern structure was planned for the 1919 term. It was near Flat Rock Road (2002) and Hays Road. The class picture above was taken outside of the new building.

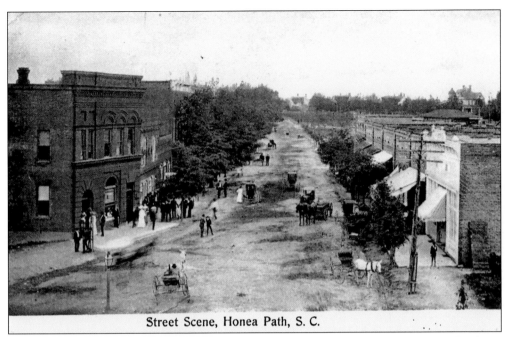

Street Scene, Honea Path, S. C.

STREET SCENE, HONEA PATH, [c. 1900.] This postcard view of Main Street, looking north, shows the small business district of this community in 1900. An 1897 map of Honea Path indicates Main Street stores on the left were owned by W.A. and R.M. Shirley; J.W., L.A., and T.H. Brock; T.J. Clatworthy; and the Farmers Alliance. On the right were the town council offices, warehouses, and other retail stores.

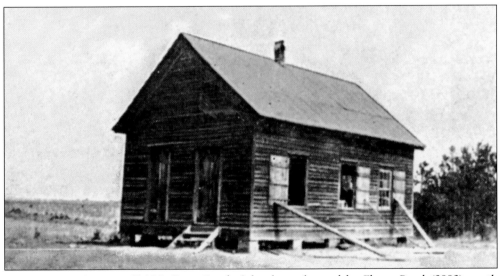

[CROSS ROADS SCHOOL, 1918.] Cross Roads School was located by Ebney Road (2002) south of U.S. 76 and S.C. 252. In 1900 Broadway School District #11 had two African-American 1-teacher schools with 197 students. By the second decade this area was renamed Neals Creek School District #60. The image above shows the typical rural schoolhouse built by the community without county or state funding. The children were lucky if they were warm and dry in the winter.

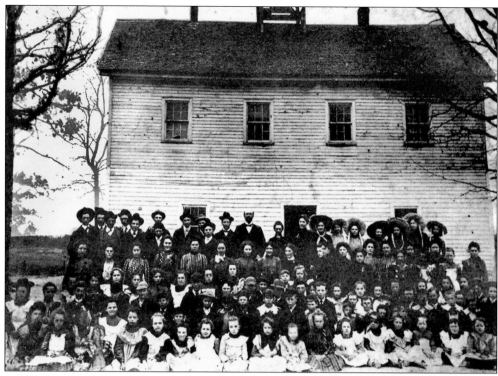

[HONEA PATH SCHOOL CLASS, 1878.] Honea Path's first school was established in 1810. A two-story frame school on South Main Street was erected in 1878 and had an auditorium and two smaller classrooms with the second floor used for physical education. H.G. Reed was the head of this school in 1879. The 1900 Honea Path School District #16 had 7 white schools, 10 teachers, and 399 students.

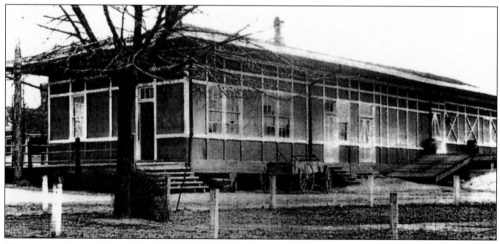

[SOUTHERN DEPOT, HONEA PATH, C. 1930S.] The Honea Path area obtained train service when the Greenville and Columbia Railroad established a depot in 1853. This line and other local railroads were obtained by the regional Southern Railway System in 1894. The second railroad line there was the Piedmont and Northern Railroad in 1911. The Southern's depot was torn down in 1970, while the latter depot stands and is used for other purposes in 2002.

FALL MILLINERY, T.H. BROCK AND COMPANY,
[1907.] This T.H. Brock postcard advertises the
initial showing of the fall display of new hats in
1907. The national company that marketed these
hats also printed this generic advertising postcard
with a sample picture of their new line of hats.
A lower blank section allowed space for each
retailer to place the relevant dates and locations.
Brock's store was located on the left side of Main
Street, as shown on page 97.

OUR FIRST SHOWING OF
FALL MILLINERY
WILL BE ON
THURSDAY OCTOBER 3RD
CORRECT STYLES WORKMANSHIP AND PRICES
T. H. BROCK & CO.
HONEA PATH, S. C.

PUBLIC SCHOOL, HONEA PATH, [1907.] An 8-
classroom and auditorium brick graded school
was built in 1904 on the site of the old two-
story frame structure. The school's library was
established in 1905. An increased student body
caused the school to be enlarged in 1911. In
1918 the brick school had 10 teachers in grades
1 through 11 with 438 students. The mill had a
frame school in the village with 3 teachers for
grades 1 through 4. The brick school was razed
in the late 1940s.

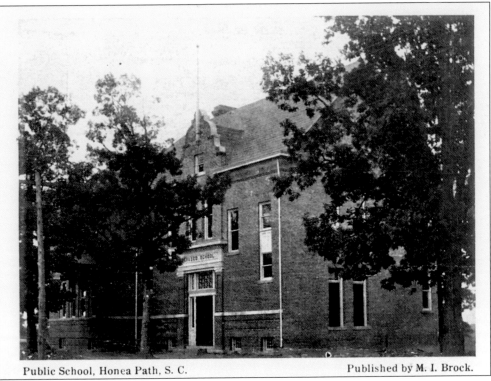

Public School, Honea Path, S. C. Published by M. I. Brock.

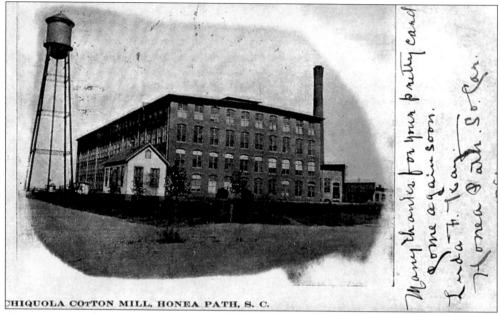

CHIQUOLA COTTON MILL, HONEA PATH, S. C.

CHIQUOLA MILL [c. 1909.] Chiquola Mill began operations in 1903 in a 4-story building on a 96-acre site that included a village with 35 4-room cottages. It began with 15,360 spindles and 400 draper looms and later expanded to 40,320 spindles and 1,000 looms that annually consumed 5,500 bales of cotton to create fabric worth $600,000 and a payroll of $100,000. The village housed a population of 1,000 that included 400 operatives. A 1934 union strike, a part of a nationwide strike, resulted in 6 men being killed.

[MONROE BROTHERS DEPARTMENT STORE, HONEA PATH, C. 1900.] The Monroe Brothers Department Store stocked clothing, kitchenware, furniture, notions, and hardware. This 1900 interior view shows this store's collection of buggies and related supplies. Local merchants would hire traveling sales promoters to create carnival-style activities to move slow-selling merchandise.

TRINITY METHODIST CHURCH, HONEA PATH, [*c.* **1910.**] The Trinity Methodist Church was organized in 1870. Rev. J.W. Murray was the pastor of the Cokesbury District, which included Honea Path, and was the initial visiting minister. Rev. E.W. Mason was first resident pastor. The South Main Street edifice was erected in 1907.

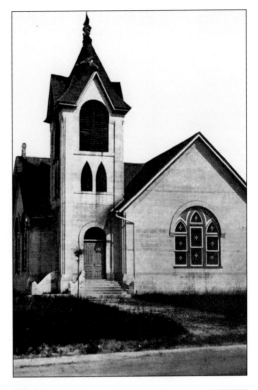

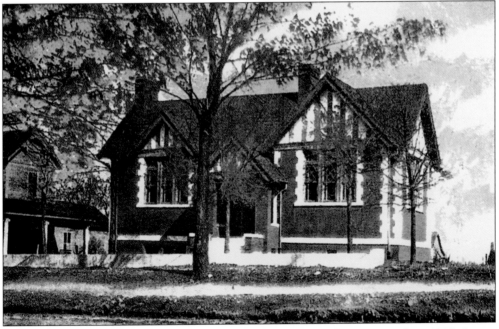

J. ERWIN LIBRARY, HONEA PATH, [**1910.**] The Jennie Erwin Library opened in 1908. It was supported by the Carnegie Foundation that gave $5,000 to build the library; J. Erwin donated $1,000 to buy books. Miss C. McGee was the first librarian from 1907 to 1921 and Miss L. Gassaway was the librarian from 1924 to 1931.

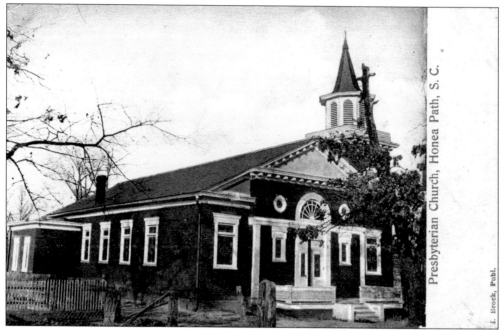

Presbyterian Church, Honea Path, S. C.

L. Brock, Publ.

PRESBYTERIAN CHURCH, HONEA PATH, [1908.] The Presbyterian Church was organized in 1860 and was the first church in Honea Path. The congregation was served by traveling ministers who visited several churches in the local district. Rev. J.T. McBride came to this church in 1894.

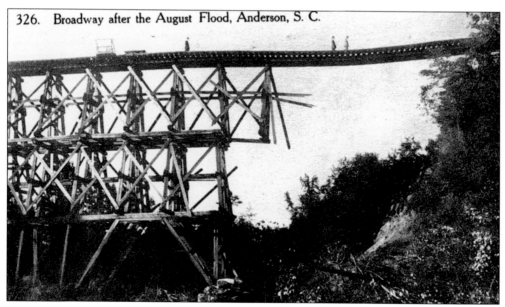

326. Broadway after the August Flood, Anderson, S. C.

BROADWAY BRIDGE AFTER THE FLOOD. This railroad trestle over Broadway Creek was on the Inter-Urban Line that ran from Anderson to Belton. The 76-foot-high trestle and all the county bridges were washed away when 11 inches fell in 20 hours on August 25, 1908. The Democratic primary was held that day but the winners were not determined for a week. Young children were hired for $6 a month to walk these wood trestles with a water bucket after each crossing of the wood-burning locomotives to put out any small fires.

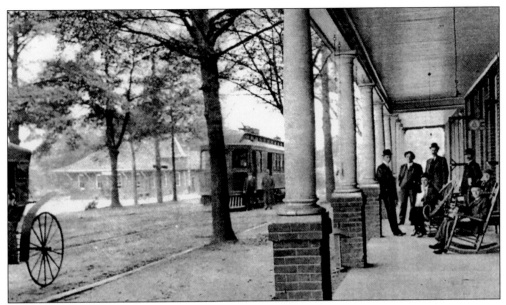

VIEW NORTHWEST FROM HOTEL GEER, BELTON, [C. 1908.] The Inter-Urban Railway connected Belton to the Anderson County courthouse. Passengers from the courthouse would ride the Inter-Urban electric car and arrive at Hotel Geer's front piazza depot on the northwest side of Belton's square. An electric car is shown in the postcard image above. If they wanted to travel to Columbia or Greenville, they would cross the square to the railroad station seen in the distance behind the car.

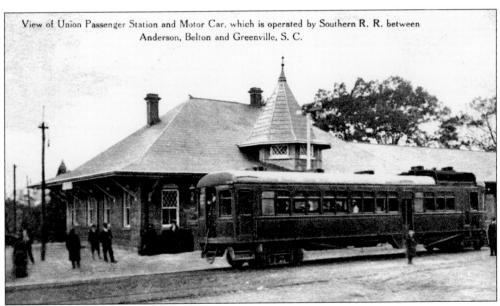

View of Union Passenger Station and Motor Car, which is operated by Southern R. R. between Anderson, Belton and Greenville, S. C.

VIEW OF UNION PASSENGER STATION AND MOTOR CAR, BELTON [C. 1915.] The Greenville & Columbia Railroad erected a depot at this site, which was to become Belton in 1853. Within two months a ten-mile spur was built to Broadway trestle and then on to Anderson village. In 1894 the Greenville & Columbia Railroad became the Southern Rail Road. The view above shows the Belton depot and a coach of the Piedmont and Northern Railway Company.

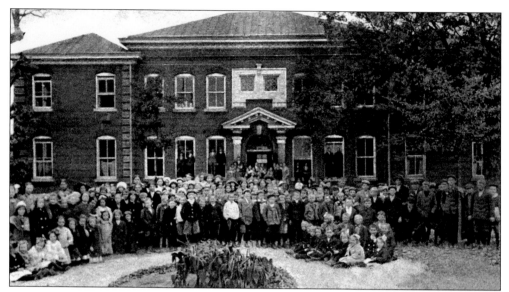

CENTRAL GRADED SCHOOL, BELTON [1910.] Belton School District #12 in 1900 had 4 white schools and 6 teachers with 205 students. The Central Graded School established its library in 1905. The 2-story brick school was erected in 1910 and later expanded to 11 rooms. The mill school had grades 1 through 5. In 1918 the Central school had 705 students and 15 teachers in grades 1 through 11 during a 138-day session.

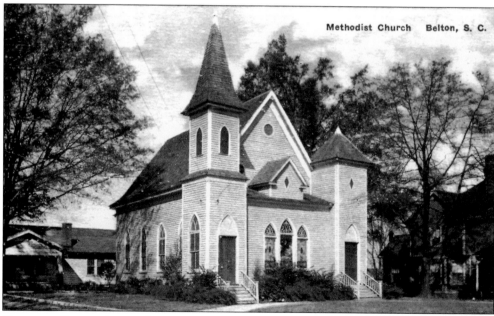

METHODIST CHURCH, BELTON, [c. 1910.] The Latimer Memorial Methodist Episcopal Church, South evolved from a three-day meeting held in the Presbyterian Church in 1858. The congregation was organized in 1876 and continued to meet in the Presbyterian Church until 1882 when a frame meeting house was built. In 1900 a tower and steeple were added. The church was renamed after United States Senator Asbury Churchwell Latimer in 1911. The initial remodeled structure is still in use.

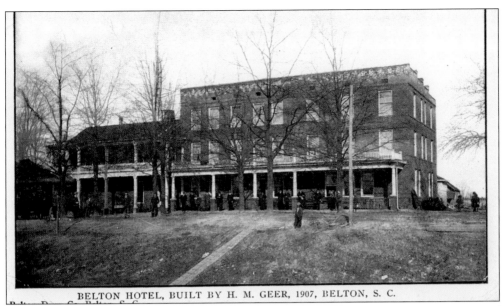

BELTON HOTEL, BUILT BY H. M. GEER, 1907, BELTON, S. C.

BELTON HOTEL, BELTON, [c. 1914.] The Belton Hotel was built by H.M. Geer in 1907. The hotel became the Belton depot of the 10-mile electric Inter-Urban Railway that connected the town of Anderson to Greenville or Columbia. On special occasions individuals would take a trip to Belton and have a fine dinner at the Geer Hotel before returning to Anderson.

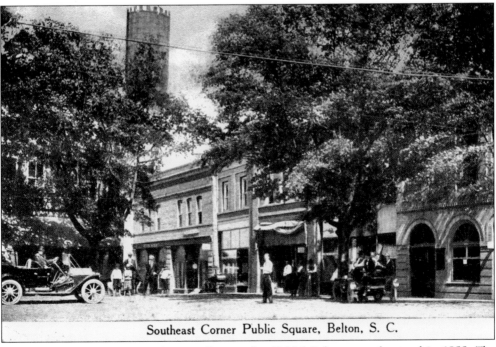

Southeast Corner Public Square, Belton, S. C.

SOUTHEAST CORNER OF PUBLIC SQUARE, BELTON, [c. 1911.] Belton was chartered in 1855. The southeast corner included the Fair Pharmacy. This view shows the top of the Standpipe in the background that was built in 1909 at a cost of $22,500. It stands 155 feet above ground and 30 feet below and holds 150,000 gallons of water. Belton's population in 1910 was 2,000.

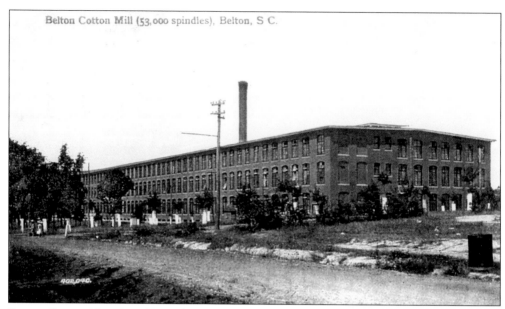

Belton Cotton Mill (53,000 spindles), Belton, S C.

BELTON COTTON MILL, [c. 1908.] The Belton Cotton Mill was established in 1900. In 1906 it had 700 operatives with a payroll of $175,000 and a village population of 2,500 people, including 400 children under 12 years old. The mill had 53,000 spindles for spinning thread and 1,250 looms that produced sheeting, shirting, and drills. It consumed 12,000 bales of cotton annually and produced fabric valued at $1,500,000. The mill built a village school costing $5,000 for 210 children and 5 teachers.

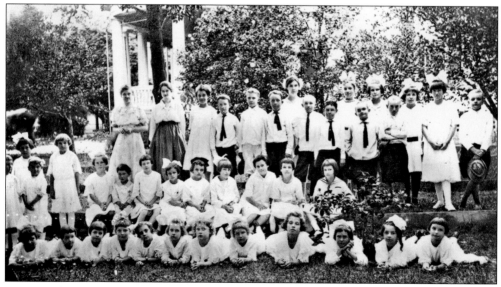

[SUNBEAM BAND, BELTON, 1914.] A singing convention met in Belton in 1869 to expand music standards. Churches sent members to Belton to improve their local choirs. Belton's Baptist Women Missionary Union was organized in 1881 and supported church music using their organ, choirs, and youth organizations like the 1886 young girls' Sunbeam Band. The first boys organization was the "Entzminger Band." The 1914 image above shows young girls and boys of the First Baptist Church's Sunbeam Band.

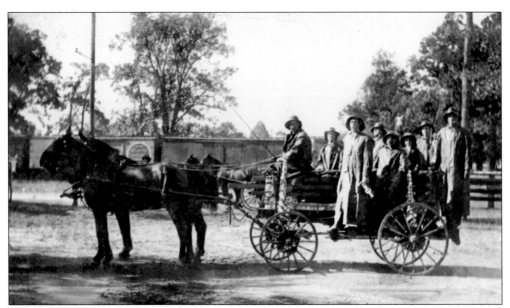

[FIRE DEPARTMENT, BELTON, c. 1911.] South Carolina towns were subject to drastic fires that destroyed their business sections. This image above shows the volunteer fire department that Belton supported. Many of the fires were in frame buildings that were lighted by gas lanterns. When brick buildings and electric lighting were in place, the fires were fewer in number.

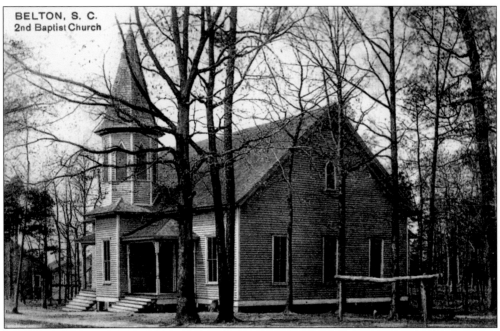

[SECOND BAPTIST CHURCH, BELTON, c. 1908.] The Second Baptist Church shown above was one of the mill churches. The mill supported two churches for the 2,000 operatives and families and gave $500 to construct each church and $50 per annum to the churches to help pay part of the monthly expenses. The Second Baptist church's minister was J.T. Wrenn and its membership was 244 in 1909.

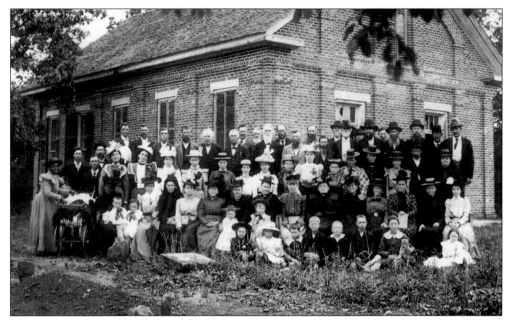

[BIG CREEK BAPTIST CHURCH, 1898.] The Big Creek Baptist Church, the initial Baptist Church of this county, was constituted in 1789. Moses Holland, a pioneer preacher from Virginia, served this church from 1788 to 1829. The minister was H.K. Williams when it had 127 members in 1909. The building shown above was erected in 1875 on the site of the initial one, three miles from Williamston near the Saluda River. It is located on Cannon Bottom Road (2002).

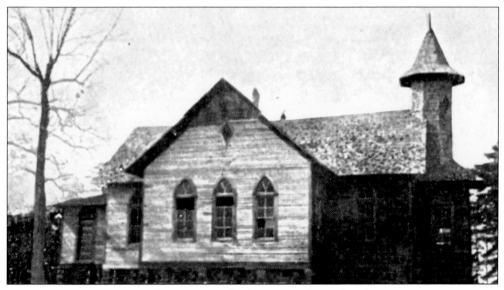

[EVERGREEN CHURCH, 1918.] The 1937 State highway map shows the African-American Evergreen Church and School at the same site. In 2002 the site was by Williamsburg Road and Evergreen Road and just south of U.S. I-85. This school site was located in the 1900 Hopewell School District #7 that had two black 1-teacher schools with 113 students. The Evergreen Church sponsored their school that initially met in their sanctuary. The 1918 school survey had this site in Cross Roads School District #31.

[FIRST BAPTIST CHURCH, BELTON, 1888.]
First Baptist Church of Belton was
organized in 1861, eight years after the
Greenville and Columbia railroad center
of Belton was founded. The first 1-room
structure was built and dedicated on
November 2, 1862. Rev. Amaziah Rice
was the first pastor. The second sanctuary
above was built by J.H. Wren of Due West
in 1888 at a cost of $2,325. The third
edifice was erected in 1911.

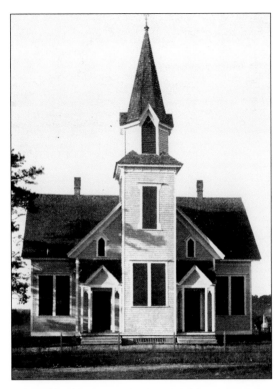

[COVERED BRIDGE, SALUDA RIVER, c. 1908.] This covered bridge crossed the Saluda River on Anderson County's southeast corner near Honea Path. On August 25, 1908 all the wooden bridges in Anderson County were washed out when 11 inches of rain fell in 20 hours. Only a few of the well-built steel bridges on the Saluda and Savannah Rivers were left standing after that deluge. This bridge may have preceded the bridge that now is used by U.S. Highway 76.

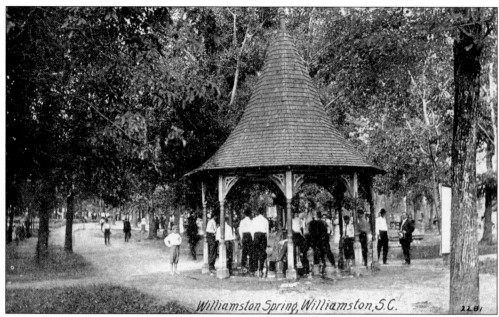

WILLIAMSTON SPRING, [C. 1908.] Williamston Spring was discovered in 1845 and a park was created around it. The mineral waters contained carbonate of iron, sulfate of potash, and magnesia. About 1853 both a hotel and the railroad depot were established. The town advertised itself as the "Saratoga of the South" and many came to drink the medicinal waters. The postcard view shows the spring's gazebo and park where picnics and events were held.

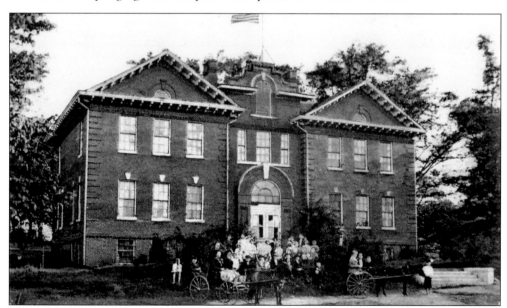

SCHOOL BUILDING, WILLIAMSTON, [C. 1908.] The George Goodgion School, a three-story brick building, was erected in 1904 on the site of the old frame one. It had four classrooms on the first floor, and two classrooms and an auditorium on the second floor. A basement room was also used for classes. It became Williamston High School in 1918. At that time 9 teachers taught 464 students in grades 1 through 10. A frame mill school was also in use.

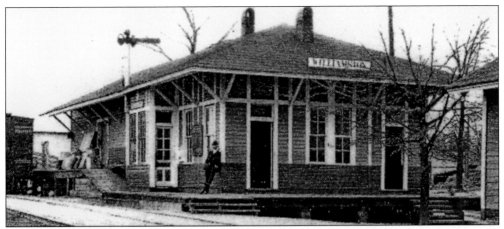

[SOUTHERN DEPOT, WILLIAMSTON, c. 1930s.] The Greenville and Columbia Railroad had completed the railway and created depots at seven Anderson locations including Williamston in 1853. The Piedmont and Western Railway Company, the first electric-powered railroad, began grading in July 1911 and trains were passing through Williamston in 1912. The Southern discontinued all service in 1982.

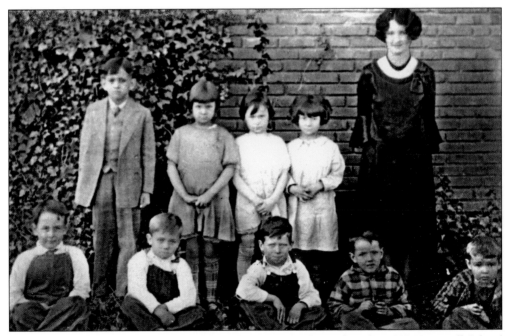

[HAMMOND SCHOOL CLASS, 1929.] Hammond School was located in the 1900 Hopewell School District #7, which had 6 white schools, 8 teachers, and 238 students and two black 1-teacher schools with 113 students. Later, Garvin District #3 was discontinued and Hammond School became District #3. In 1918 Hammond was a 2-teacher, 1-story school with 69 students in a 170-day term. It was located between A.C. 331 and A.C. 370.

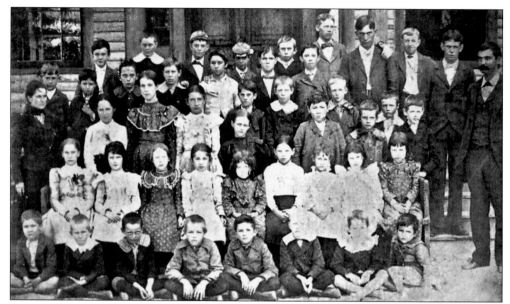

[WILLIAMSTON SCHOOL STUDENTS, 1900.] The 1850 census listed four school teachers in Williamston and for a period of time the town had an Academy for Boys and a Female High School. In 1896 a frame high school was constructed and served Williamston as the main public school. In 1900 Williamston School District #8 had seven white 1-teacher schools with 474 students while the black division had three 1-teacher schools with 186 students.

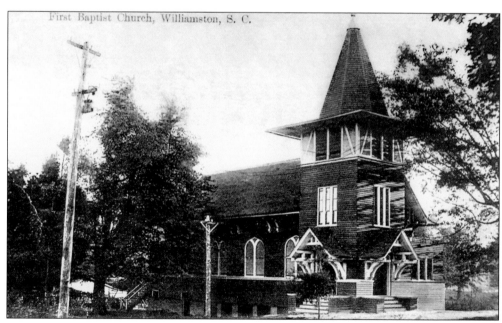

FIRST BAPTIST CHURCH, WILLIAMSTON [c. 1908.] The First Baptist Church was organized in 1855 with its first building erected in 1857. This structure was burnt in 1904 and its new Gothic edifice, costing more than $4,000, was dedicated in May 1906. The congregation had two services per month. The sanctuary could seat 250. In 1909 Rev. L.J. Bristow was the minister with 136 members.

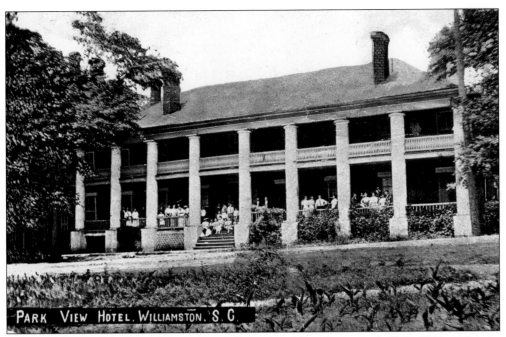

PARK VIEW HOTEL, WILLIAMSTON. S. C.

PARK VIEW HOTEL, WILLIAMSTON [*c. 1907.*] The hotel building above was built in 1873 on the site of the earlier Mammoth Hotel. A stock company was organized in 1872 by Dr. Samuel Lander to purchase property, construct a school building, and establish the Williamston Female College. When the school moved to Greenwood in 1904 the building became the Park View Hotel. Later it became the Colonial Hotel *c.* 1911 before closing in 1924. It then was used as an elementary school building until it was torn down *c.* 1940.

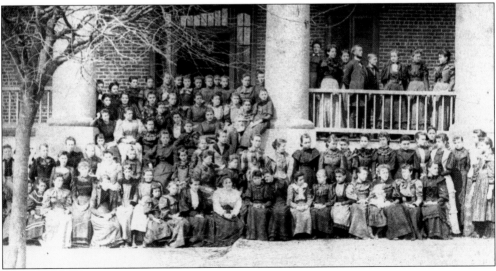

[WILLIAMSTON FEMALE COLLEGE CLASS, 1890s.] The Williamston Female College was founded in 1872 by the Rev. Samuel Lander, a Methodist minister. There were 36 students at the beginning the first term and 60 at the end of the first year that initially met in a refurbished Mammoth Hotel. The college had low charges, a spirit of economy in every activity, and classes in art and music. The college shifted to Greenwood in 1904 and became known as Lander College.

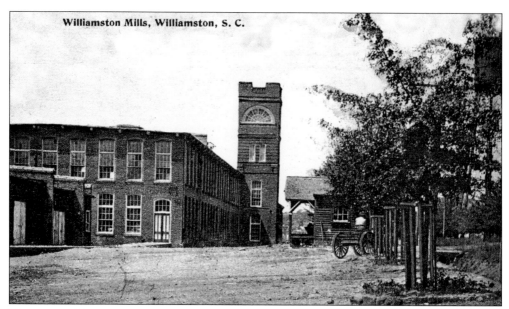

WILLIAMSTON MILLS, [*c.* 1910.] Williamston Mills plant was constructed in 1901 and was powered by steam to fabricate print cloth. In 1904 a hydroelectric plant at Holiday Shoals on the Saluda River was built and that electrical power ran Williamston Mills. The mill expanded and had 32,256 spindles and 816 looms in 1906 that processed 4,000 bales of cotton while making a product valued at $400,000. It employed 250 operatives with a payroll of $80,000. The village had a population of 500 who lived in 99 4-room cottages and 11 6-room houses at a rent of 50¢ a room per month.

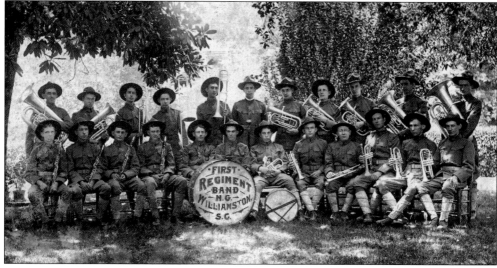

FIRST REGIMENT BAND, NATIONAL GUARD, WILLIAMSTON [*c.* 1917.] This pre–World War I band, made up of mill operatives, played at various parades, and social and cultural events at local festivals. Being one of many National Guard units they likely entertained at statewide National Guard meetings. They were a part of the First South Carolina Regiment of the National Guard and saw service in 1916 in Texas and then became the 118th Infantry, Company C that was merged into 30th Division in World War I.

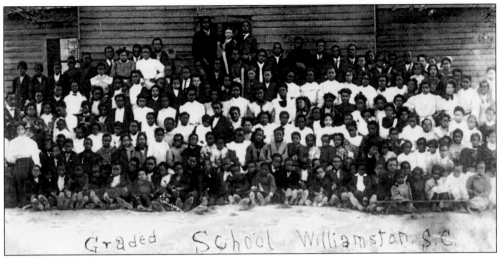

Graded School Williamston. S.C.

[CAROLINE GRADED SCHOOL CHILDREN, c. 1908.] Caroline Graded School for African-American children was established in 1870 by Forest Washington on the grounds of New Prospect Baptist Church. The second site was at Bethel Episcopal Methodist Church where Prof. A.C. Garrison was principal and teacher from 1890 to 1908. A 4-room schoolhouse was erected on Mattison Street behind Bethel Methodist Church in 1908. This student picture of 1908 is made in front of this new schoolhouse.

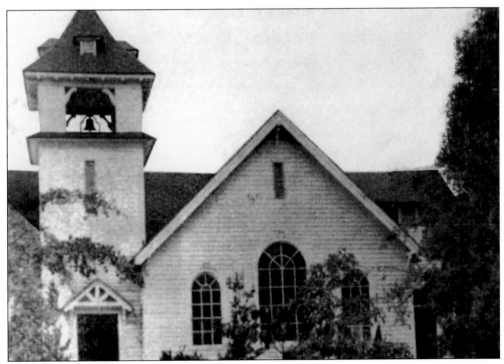

[NEW PROSPECT BAPTIST CHURCH, WILLIAMSTON, c. 1925.] The New Prospect Baptist Church was organized in 1870 when African-American members of the Big Creek Baptist Church decided that they wanted a church of their own. Rev. Frank Morris organized New Prospect in 1870. The initial log cabin was replaced by a rough frame structure. In 1918 the sanctuary above was erected.

115

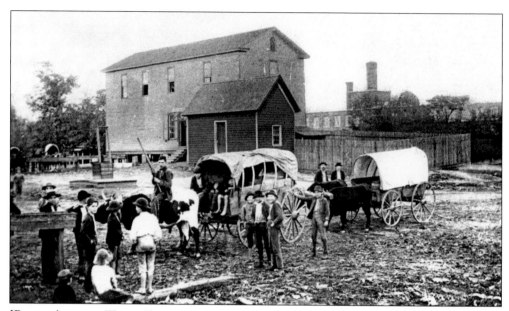

[PEDDLER'S IN THE WAGON YARD, PELZER, 1893.] Rural mountain families' income in the 1890s would come from sales of produce, fruits, nuts, and other goods during harvest seasons. They would bring these items to peddle in small towns. The scene above was photographed in October 1893 in the Pelzer Mills wagon yard.

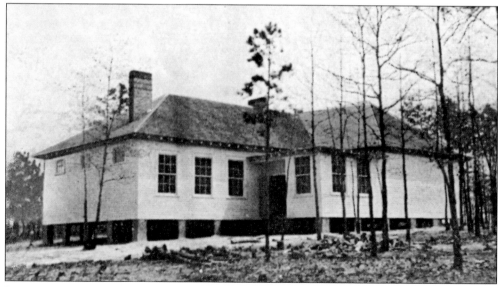

[LONG BRANCH SCHOOL, 1918.] Long Branch Baptist Church and School were marked at the same site on the 1897 county map on the northern edge of Martin Township. The 1900 Long Branch School District #33 had a 1-room school with 67 students. It established a library in 1909. The 1918 survey found a new 3-teacher school at a nearby site. It had 81 students in grades 1 through 7 and 12 in the upper 8 through 10 levels in a 140-day term. It was located near S.C. 413 and Long Branch Lane (2002).

116

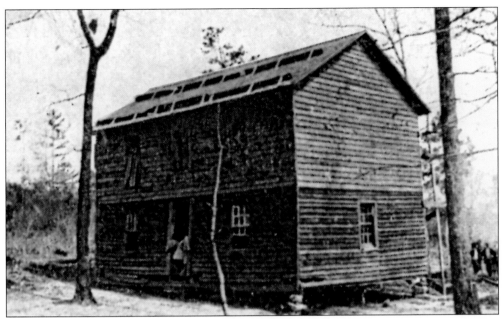

[**MT. PLEASANT SCHOOL, 1918.**] Mt. Pleasant School was located between Midway and Ballard Roads (2002). In 1900 this site was in the Williamston School District #8, which had three black 1-teacher schools with 186 students. After the first decade the area was renamed the Beaverdam School District #56. This 1918 school picture shows a larger than normal structure.

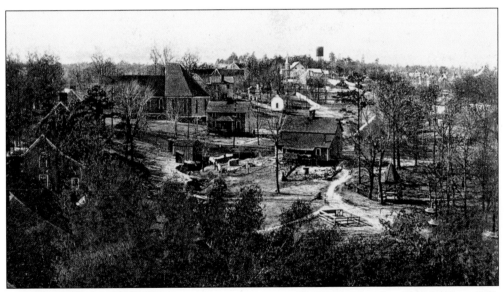

VIEW OF PELZER, SOUTH CAROLINA LOOKING WEST FROM UNION CHURCH, [c. 1910.] Pelzer Mills were built by Wilson's Shoals on the Saluda River. The mill was organized in 1880 with Mill #1 operating in 1883 and Mill #2 in 1885. Mills #1, 2, and 3 required 5,000,000 bricks that were made on-site. Each mill had four stories with weaving on the first two floors, carding on the third floor, and spinning on the fourth floor. Mill #3 (1888) was powered by steam from coal-burning furnaces. The three mills had 52,000 spindles and 1,600 looms, which wove a lighter-weight yarn for cotton sheetings and drills. Mill #4 began in 1895 and is shown on page 95.

FOURTH GRADE, PELZER GRADED SCHOOL [c. 1915.] The first mill school was organized in 1882 with 13 students and was open 10 months a year. Seventy-five percent of the mill workers in 1884 could not read or write, but by 1902 only 20 percent were illiterate. The operatives were mainly from rural families from area farms and the mountains. In 1902 the mill began compulsory education.

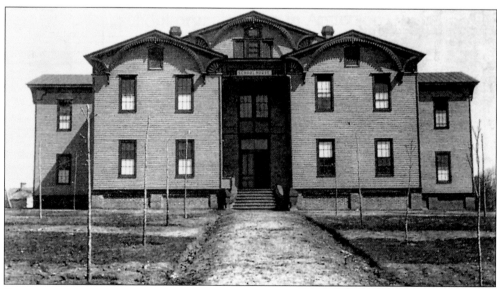

[PELZER SCHOOL, 1900.] The second schoolhouse was built in 1900 on the corner of Lebby and Hale Streets. The Pelzer School District #22 in 1900 had 8 teachers instructing 673 students, which expanded to 800 and included night classes in 1901. The school above was burned in 1902 and rebuilt in 1903. The mill invested $13,000 in school buildings with $3,700 spent annually for schools; all were in mill village. The high school was organized in 1916 with 14 teachers.

118

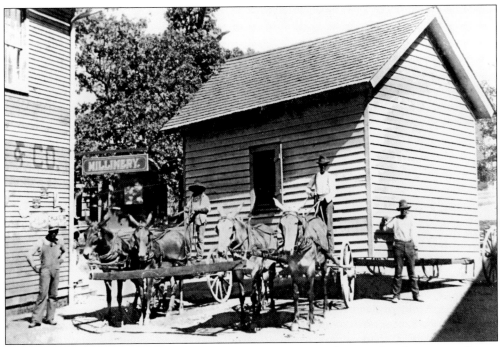

[MOVING BUILDING, PELZER, 1899.] In this era large or heavy loads were placed on wagon frames and pulled very slowly by mules or oxen from site to site. The route was chosen carefully to avoid muddy sections where the wagons could become stuck.

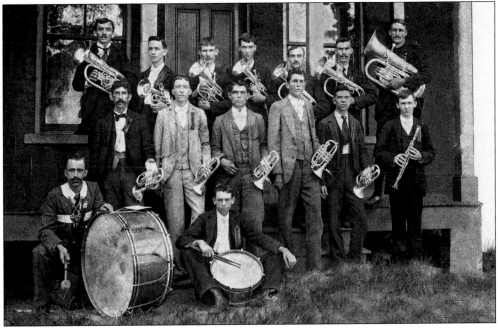

[SMYTH'S CONCERT BAND, PELZER, 1893.]. Smyth's Concert Band was established in the late 1880s and was directed by R.W. Hembree. The 1893 picture above of the brass band shows musicians who were Pelzer Mill operatives.

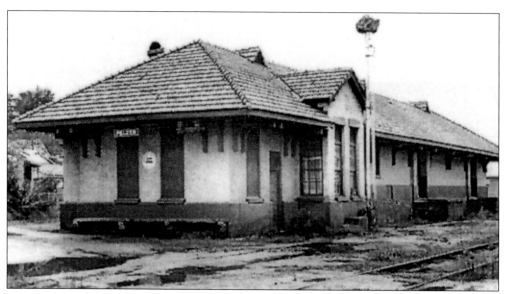

[PIEDMONT & NORTHERN RAILROAD DEPOT, PELZER, *c.* 1930s.] The depot above was on the electric Piedmont & Northern Railroad line that was established in 1912. This line used lightweight electrical coaches that passed substations where the 2,200-volt alternating current was converted to 1,500-volt direct current required by the electric locomotives. The South Carolina division ran 98 miles from Spartanburg to Greenwood. Pelzer's population in 1910 was 1,500.

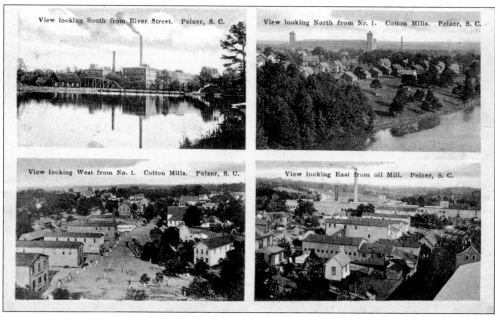

VIEWS FROM PELZER MILLS, [*c.* 1908.] Pelzer mills #1 (1883) and #2 (1885) were powered by water that used a granite dam across the Saluda River. The dam was 18 feet wide at the base and tapered to 10 feet wide at the top, and it was 21 feet high and 300 feet long. Thus, a pond was formed behind the dam and water was forced into a canal 42 feet wide and 17 feet deep. The canal went under the end of mill #1, and turned a large water wheel that created 1,000 to 1,500 horsepower for the two mills.

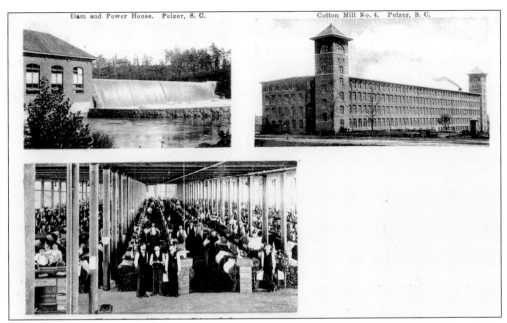

DAM AND POWER HOUSE, COTTON MILL #4, [*c.* 1908.] The 1895 mill #4 had 55,000 spindles and 1,600 looms, which created a 4-mill total of 130,000 spindles and 3,200 looms. The dam at Holland Shoals was 700 feet long, 40 feet high, and 36 feet wide at the base and 6 feet wide at the top. The station had five water tubes installed with five General Electric generators of 750 kilowatts. The electricity was generated by a power station three miles downstream and traveled by wire to the distant mill. Thirty-six thousand bales were processed annually with a product value of $2,500,000. An aerial view is on page 95.

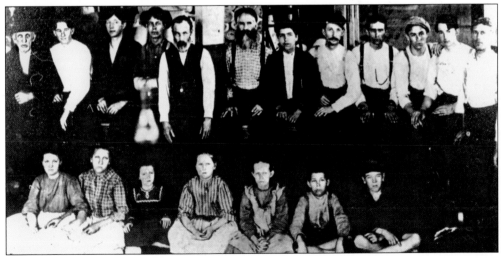

[OPERATIVES, PELZER MILL, *c.* 1907.] Mill operatives earned an average wage of $1.10 per day in 1906. Full-time operatives worked 62 hours a week. The mill employed 3 boys and 6 girls under the age of 12 years. A 5-operative family of father, mother, and three children earned about $7 a day and spent about $4 for food every 2 weeks. By 1906 the four Pelzer Mills employed 2,000 operatives who lived in a mill village with a population of 4,500. Pelzer Mills's payroll was $425,000.

[NATIONAL GUARD, STRIKE, PELZER MILLS, 1935.] On July 15, 1935 a partial walkout strike of 300 members of the United Textile Workers union closed Pelzer Mill on July 16. National Guard units were sent to keep order. Martial law was in force from August 3 to September 2 in Pelzer. On Labor Day, Monday, September 2, shots were fired at Pelzer Mills and Mrs. Bertha Kelly, 21, was killed and 13 were wounded. National Guard units returned and stayed until September 16th.

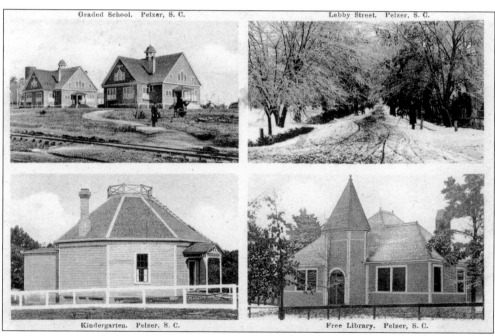

GRADED SCHOOL, LIBRARY, KINDERGARTEN, PELZER, [C. 1915.] This postcard shows the graded school, the kindergarten, and free library. The kindergarten had 120 children in 1907. In 1918 Pelzer had two school buildings, one for elementary grades and one for upper-level grades with 832 students taught by 18 teachers. The night school met 4 times a week with 75 pupils in grades 1 through 7. Pelzer's library had 6,000 volumes.

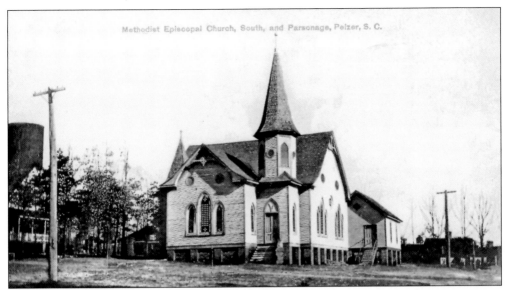

METHODIST EPISCOPAL CHURCH, SOUTH AND PARSONAGE [*c.* 1908.] The Methodist Church was organized *c.* 1882 and in 1891 it had 471 members. Rev. J.C. Stall was the first pastor of this circuit, which included Williamston and Belton. The congregation built the church above in 1902. Pelzer Mill supported six churches, spent $9,500 to build the sanctuaries, and gave $500 annually to the churches that had a total membership of 900.

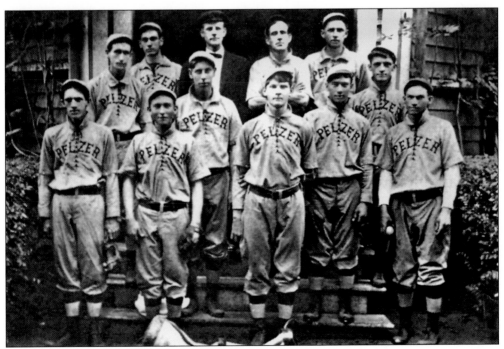

[PELZER BASEBALL TEAM, 1912.] The Pelzer Mills baseball team was established in the 1880s. Independence Day festivities often included parades, picnics, and baseball games, such as the 1915 game that had Pelzer Mills winning 3–1 over Piedmont Mills in front of a crowd of 4,000. The 1915 team was the champion of the Interurban League.

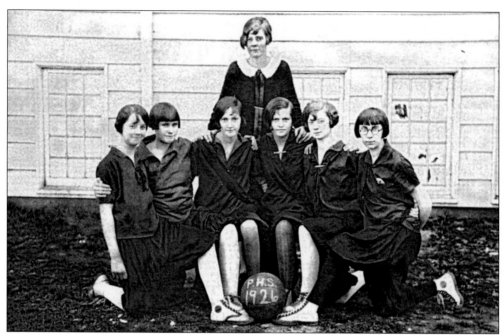

[DISTRICT HIGH SCHOOL CHAMPS, 1926, PELZER.] In the 1920s Pelzer District School had over 750 students, 23 teachers, and 22 classrooms in four buildings. A night school had 125 adults enrolled. Students excelled in football, basketball, and baseball. The image above shows the 1926 District High School girls basketball team coached by Ruby Merchant.

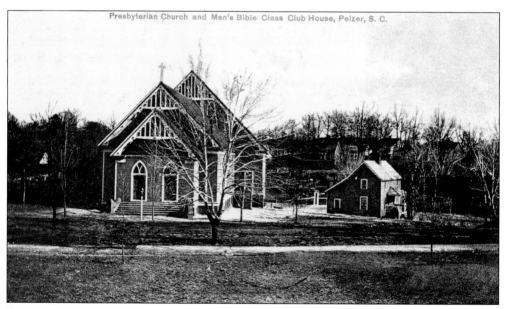

PRESBYTERIAN CHURCH AND MEN'S BIBLE CLASS CLUB HOUSE, PELZER [c. 1910.] Pelzer's Presbyterian Church was organized in 1883 and the Rev. Calvin L. Stewart was the first minister. He also served the mill churches in Piedmont, Williamston, and Honea Path. The church above was erected in 1896. A new pipe organ was installed in 1897 when the church had a membership of 142. In 1905 a modern Sunday school building was constructed.

124